BANKSY

LOCATIONS & TOURS
VOL 2

A COLLECTION OF GRAFFITI LOCATIONS
AND PHOTOGRAPHS FROM AROUND THE UK

MARTIN BULL

US EDITION

BANKSY LOCATIONS & TOURS VOL 2
A COLLECTION OF GRAFFITI LOCATIONS AND PHOTOGRAPHS FROM AROUND THE UK
The author asserts his moral right to be identified as the author of this work.
Copyright © Martin Bull
This edition copyright © 2011 PM Press

ISBN: 978-1-60486-330-7
Library of Congress Control Number: 2011927946

10 9 8 7 6 5 4 3 2 1

Based on a design by Courtney Utt

PM Press
PO Box 23912
Oakland, CA 94623
www.pmpress.org

Printed in Canada on recycled paper with union labor.

CONTENTS

INTRODUCTION

"WE MAKE A LIVING BY WHAT WE GET,
BUT WE MAKE A LIFE BY WHAT WE GIVE"

THE GEEKY BIT

BUY BYE BYE, SALE SELL SELL

THANKS & ACKNOWLEDGEMENTS

CREDITS

WEB LINKS

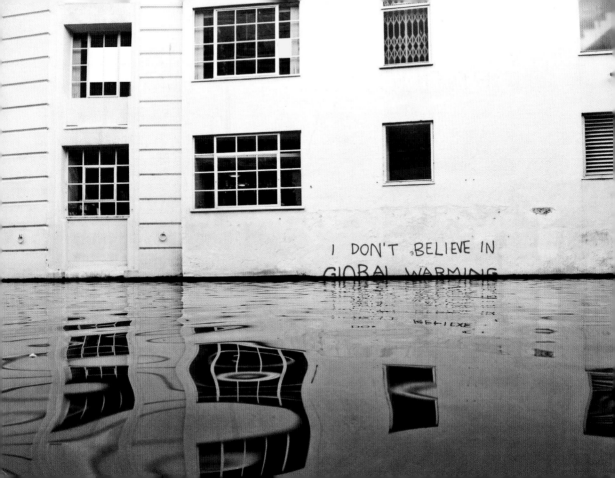

INTRODUCTION

Do you fancy wandering the streets of Britain's top graffiti cities looking for Banksy graffiti? Or do you prefer just sitting at home in your comfy chair (slippers and pipe optional, but highly recommended in these days of weapons of mass destruction), finding out more about his fascinating street work?

This unique, 100% unofficial, and unashamedly DIY book lets you do either.

Collect all the locations like a geek or just wander around, stop at the various quirky local attractions and explore parts you may never have visited before. Who knows what might happen? It's all up to you.

Following the unlikely success of my 2006 self-published book *Banksy Locations & Tours*, which grouped 65 other locations of Banksy street art into walking tours of three distinct areas of London, I decided to shamelessly re-hash that old formula by rounding up the rest of Banksy street work in the UK.

So this book takes you through over 58 more locations of Banksy street work from the present and the recent past in London, Bristol and the West Country, Brighton and the South Coast, and Liverpool, telling you where each piece is (including postcodes and approximate map/GPS references), a bit of history, random facts and idle chit-chat,

some of my photos, and the condition of the graffiti (as of May 2011 usually).

Don't expect pseudo-intellectual ramblings in this book on what this graffiti all means, how the Banksy phenomenon has taken off, who he is, who he isn't, when graffiti becomes art, or what the difference is between graffiti and street art. I'm not that interested in intellectualising all this. This book is a Nathan Barley free zone and at the end of the day it's just a (very talented) grown man doing what he enjoys in life, including creeping around at night getting sweaty and dirty – how less intellectual can you get?

I'll let you decide what it means to you and whether you think it's on a positive tip.

Martin Bull

"WE MAKE A LIVING BY WHAT WE GET, BUT WE MAKE A LIFE BY WHAT WE GIVE"

Winston Churchill

The author will donate 12% of his royalties to support the excellent work of the three charitable organisations below (4% to each organisation).

Bristol Mind (UK registered charity no. 1085171) does excellent work to provide a range of high-quality services which are reflective and relevant to the needs of the mental health service user community around Bristol. They also combat stigma and promote a positive image of mental health. Mental and emotional health problems can happen to anyone, at any age and from any background. I truly believe that *all* of us are just a few bad turns in life away from needing this type of help. Don't kid yourself that it couldn't be you – divorce, bereavement, redundancy, abuse,

repossession, etc. can happen to any of us, and it is often problems like those that lead to mental distress. Please visit www.bristolmind.org.uk.

Ben's Centre (UK registered charity no. 1087606) provides a 'damp' day service to street drinkers in Sheffield. It works to accept individuals where they are and acts as a bridge between an individual's chaotic street drinking lifestyle and one that enables them to fulfil their potential, whatever that may be. I was particularly impressed by an interview with the manager there who said, "Of course we want to break the cycle of addiction, but you're not going to do that until Joe Bloggs knows he's Joe Bloggs and remembers he once liked fishing on a Sunday afternoon." I like that

succinctness. Please visit http://benscentre.wordpress.com.

merls [change] is a charitable organisation that I recently set up (in accordance with the Charities Act 2006, charity registration will be applied for if annual income reaches more than £5,000). I used to work/volunteer in Ethiopia, and I've also worked and volunteered in the voluntary and community sector in England for many years. 'Merls' means 'change' (as in 'pocket change') in Amharigna, a main Ethiopian language, but 'change' in English also means the ability to amend and transform. In its very small way, 'merls' will mean change for the rural people in Ethiopia. It's not that I don't like urban people, it's just that the rural people are often forgotten in that vast country, and to me they represent the 'average Jo' of the country. All of this donation will be spent on projects, and none on the organisation's admin, travel, and other such expenses.

Update on donations from
Banksy Locations & Tours Vol 1
From an early stage I always planned to use *BLT Vol 1*, and related activity, to generate money for the Big Issue Foundation (UK registered charity no. 1049077). It seemed like a very fitting charity to use to give something back – a book of street graffiti/art helping people on the streets. My donations from various fundraising, especially the book sales, currently total over £30,000. From something that started as a bit of a DIY laugh between mates, *BLT Vol 1* actually became a real force for good.

THE GEEKY BIT...

Between 2006 and 2011 many kind people responded to my leading questions and downright Miss Marple-esque pursuit of where to find a lot of this graffiti. I also discovered a lot myself whilst wandering the streets like a stray dog, following hunches and leads, and smelling the odd lamp-post to get that authentic feel. I continued to give information and take it from various kindly sources.

In an effort to share this info and to let people take their own photos (if they want to – it's not compulsory) I have given a lot of free location information on internet groups/forums/location maps, and in 2006 I ran a series of free guided tours in London. All of this then accidentally became the raw material for *Banksy Locations* & *Tours Vol 1*. The days of my guided tours are over, though. There is not enough left to make them possible.

The Bristol tour in this book is still worth doing, though (as of May 2011), and almost half of the art at the locations in this book still exists, in a greater or lesser condition. If you want to find all this art yourself, this book (and *Vol 1*) will help. Take your own 'A to Z' street map with you though; maps are invaluable in this geeky game and will become your own comfort blanket. I will also post free updates to the info in the books on my website, which may be able to save you a wasted journey when a piece disappears. I will post free book/status updates on my own website **www.shellshockpublishing.co.uk**

And I can send these updates to you by email if you want. Just email me at **m@shellshockpublishing.co.uk**

I will continue to contribute location information on internet, especially on the following sites:
· The Banksy group on Flickr:
 www.flickr.com/groups/banksy/
· The Banksy Forum: **www.thebanksyforum.com**

BUY BYE BYE, SALE SELL SELL
(A.K.A. LEAVE THEM ON THE STREETS PLEASE!)

Without wishing to sound too grave or pompous (this is graffiti after all, where there aren't supposed to be any rules really), I feel that recent circumstances mean I need to give a summary of my personal feelings on removing, buying, and selling street pieces by Banksy. You of course have free will to do whatever you want to, hopefully using a wise conscience and internal moral compass.

First things first. I am just talking about pieces done on the streets and *not* canvases, screenprints, etc. My natural feeling has always clearly been to 'leave them on the street where they belong'. Simple as that. I don't need to intellectualise it all by going on about the utilitarian 'gift' of work to the street, and the 'democracy of street art'. Whilst people have these inane discussions, real writers are out taking risks on train tracks and climbing drainpipes.

This issue has unfortunately raised its head higher for me because some people have tried to use my first *Banksy Locations & Tours* book as a form of provenance when they are dealing in street pieces. For example, in late 2007–early 2008 the door the Refuse Store Rat in Clerkenwell was on (see Location F8 in *BLT Vol 1*) was removed, and it turned up in a Contemporary Art auction by the Scottish auctioneer Lyon & Turnball in September 2008. This auction controversially contained five Banksy street pieces, all allegedly 'authenticated' by Vermin, a company that has no connection to Banksy.

I was very unhappy when a friend told me they had referenced my book in their description of the piece. I rattled off a complaint to Lyon & Turnball, but they refused to take out the reference to *BLT*. My follow-up emails went unanswered, not surprisingly I guess, especially as the third one was childishly smug that their auction had been a colossal flop. Its estimated price was £20–25,000, but it remained unsold.

My books are a bit of fun really and are not meant to provide some sort of claim to give provenance to a street piece. I'm just a big geeky fan of Banksy's work and these are meant as information books and DIY guides. Believe it or not, these books have actually been quite hard work as well. They are not sales catalogues, nor an invitation to find pieces to steal, take to auction or buy from the owner. Banksy and Pest Control are the only people that can provide 'provenance' for anything Banksy-related (definitely not me!) and none of them will give provenance on street pieces because they don't want to. Is that an accident? No, it's because street pieces are meant for the street.

This particular auction led to a rare statement from Banksy, as reported by the *Evening Standard*. He said: "Graffiti art has a hard enough life as it is – with council workers wanting to remove it and kids wanting to draw moustaches on it,

before you add hedgefund managers wanting to chop it out and hang it over the fireplace. For the sake of keeping all street art where it belongs, **I'd encourage people not to buy anything by anybody unless it was created for sale in the first place.**" (my emboldening)

Similarly, Pest Control added a note of warning about street pieces, as it said on its website: "[Banksy] would encourage anyone wanting to purchase one of his images to do so with extreme caution, but does point out that many copies are superior in quality to the originals. Since the creation of Pest Control in January 2008 we have identified 89 street pieces... falsely attributed to the artist."

The most informative internet piece on this thorny subject can be found at http://www.thisislondon.co.uk/standard/article-23560543-banksys-dont-bank-on-it.do

LONDON

Banksy Locations & Tours Vol 1 groups 65 Banksy graffiti locations (and a few by other artists and graffiti writers) into walking tours of three distinct areas of London.

I did not mean for *this* book to be dominated by London. I saw it primarily as a round-up of *any* other Banksy graffiti all around the UK and assumed it would be quite geographically balanced. But when I sat down and counted up the locations I was a bit shocked to realise that two-thirds of the locations are actually in London again. Oh well, c'est la vie, this is another annoyingly

London-centric book then! The cold facts are that since Banksy left Bristol, circa 2000, a lot of his street pieces have been done in London and nearly every UK piece since 2005 had been done there until he started wandering a bit further in 2010.

Not surprisingly then London still has quite a few left to see, although time and local councils are now ravaging them.

At each 'live' location (i.e. ones still existing) I have given the nearest public transport link available; usually the local tube stations, but occasionally a train station or even a bus route.

LDN1

WHAT ARE YOU LOOKING AT?

This was part of the rabbit warren-style Marble Arch subway complex (Map/GPS reference: TQ 27748 80918). It was next to the toilets, which since renovation are no longer directly accessible by the subway.

This is featured in Banksy's books *Wall and Piece* and *Cut It Out*, which date it to 2004, and also in the *B Movie* added extra that was part of the *Exit Through the Gift Shop* DVD release. The iconic stencil lasted over five years, despite being in such a high-profile place!

In an article in October 2008 about the possible removal of the 'One Nation Under CCTV' piece (see Location LDN7), the BBC reported that 'What Are You Looking At?' was not being removed as the whole area is being redeveloped. By spring 2009 work had started on the area, with the subways close to the graffiti being bricked up, and equipment appearing near the Banksy but never damaging it.

But sometime between November 2009 and June 2010 it was sandblasted away, and someone sarcastically added a comment underneath the already broken CCTV camera, asking, 'Who Are You Looking at Now?' (see inset photo right).

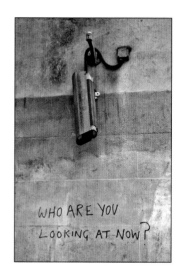

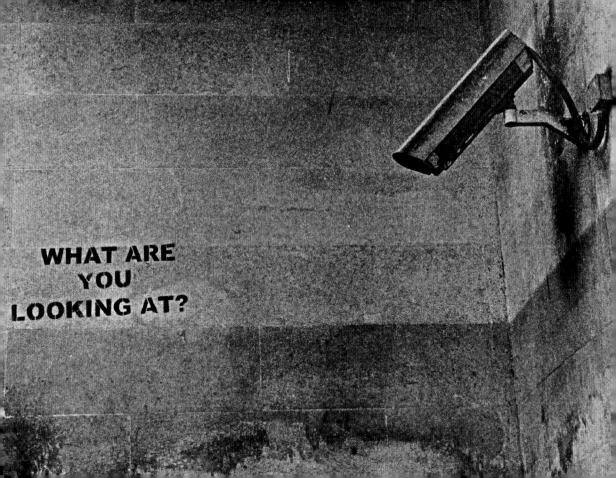

LDN2

THINK TANK
Postcode: SW1X 7PH
Map/GPS reference: TQ 27617 79716
Location & Details: Inside The Wellington Club at 116A Knightsbridge,
on the corner of a small alley called Park Close.

A rather strange one, this. This work was described by the
auctioneers Bonhams as "one of a number of studies" for the cover
of Blur's 2003 album *Think Tank*. It is done on distressed steel,
measures 155 x 135cm and was called 'Tank – Embracing Couple'
by Bonhams when they sold it for £62,400 at their Vision 21 auction
in London on 25th October 2006. It is noticeably very, very similar
to the finished album cover, with the only large difference being the
single word 'Tank' on this. It's presumably a piece done in the studio,
as opposed to some related (and slightly later) works that were done
on farm buildings in Yorkshire for the band's photo shoot for the
cover of the launch issue of the *Observer Music Monthly* magazine
in September 2003. Two of these outdoor works were later sold at
auction by Bonhams in April 2007.

 Now it rather casually hangs on a wall in an 'exclusive' club in
Knightsbridge, whatever that means. Look it up on the 'net and you
get the usual rubbish about Paris Hilton and Chelsea footballers –
it's where John Terry and Jody Morris were arrested in 2002. It
does make it hard to visit.

 Nearest tube: Knightsbridge (Piccadilly line)

Status
Fine apparently (July 2010), although it is surprising that it's not
protected. The photo shows it with a 'Free Tibet' sticker on it, which
is surely irony given where it is now located and how much it cost at
auction.

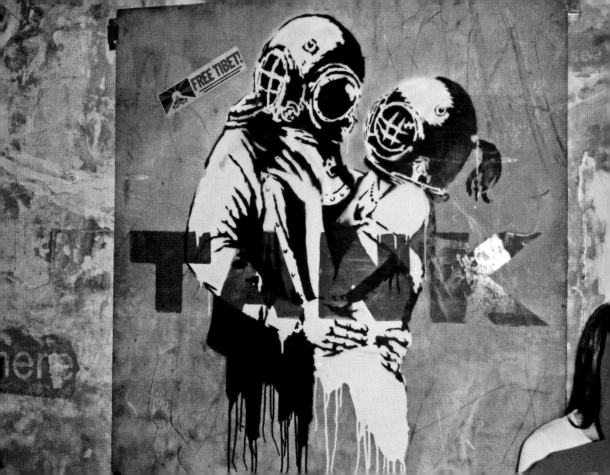

LDN3

SWISS EMBASSY CAR PARK
Postcode: W1H 2ET
Map/GPS reference: TQ 27708 81606
Location: Inside the Swiss Embassy, 16–18 Montagu Place, London, W1H 2BQ

In February 2008 a little-known secret about a nation often stereotyped as rather dull, secretive and overly conservative, suddenly got worldwide publicity. When the Swiss Embassy, in deepest central London, hosted the launch of Your Game, a charitable project run by the BBC and the Football Foundation to help young people who might be at risk of getting involved in gang culture, gun crime or substance abuse, few people knew that its underground car park contained the biggest and oldest collection of Banksy originals on walls anywhere in the world!

Photos and publicity from the launch showed a stunning array of work by Banksy and others, such as Chu, Snug and some Swiss graffiti writers. It dated back to 2001 when a project called Next Generation, designed to engage with the next generation of people and artists, ran various events through the year starting with a 'Graffiti Party' on 26th January. The artists were allowed free run in the car park and painted over two all-night sessions before the event. Banksy and Chu are no strangers, having painted together before and since this event, including at the infamous Walls on Fire event in Bristol in 1998. Chu also worked on Banksy's earlier screenprints and they later collaborated on the crime scene style tape that said 'Polite Line – Do Not Get Cross'.

Afterwards the *Guardian* reported that originally "the plan was to whitewash the walls but the embassy was pleased with the results and decided to keep the graffiti."

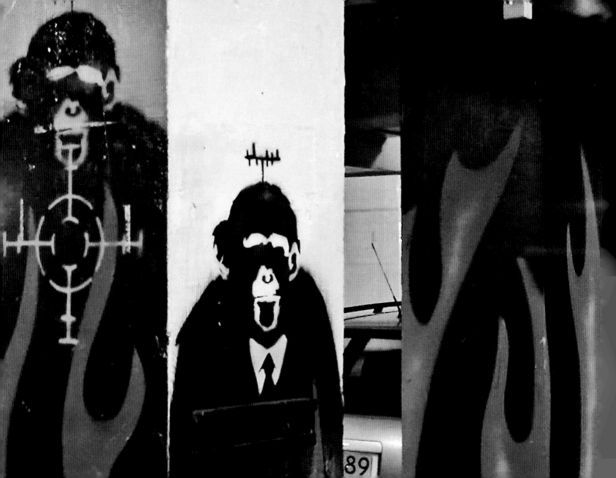

There are many pieces in there that are obviously by Banksy: a multitude of spiky-haired Lenins (labelled 'vulture capitalists'); a huge Mona Lisa with target, flames and a 'Banksy' tag (see photo right); monkeys with similar flames and targets; a security guard; 'This Is Not a Photo Opportunity'; Mickey Mouse in flames; and a dreaming poodle, which has since been taken out of the garage and into the office.

Limited information is available on the Federal Department of Foreign Affairs website (www.eda.admin.ch/london), which includes the lovely quote that participation in sport helps "young people involved in or at risk of deviant social behaviour". 'Deviant' is such an underused word these days I feel.

Status
All still fine apparently but unfortunately the Embassy doesn't seem to understand the ethos of graffiti and refuses to let people visit it, even with an appointment, security checks etc. Presumably they are happy to give the 'youth' a voice but then that voice will rapidly become the property of a posh Embassy. I've entered many embassies when I used to live in Ethiopia (and not long after a prolonged war), so I can't believe that there are insurmountable problems in allowing at least limited access to it. Maybe the stereotype of the Swiss mentality is true after all?

Rant over.

Move along now; unfortunately there's nothing to see here.

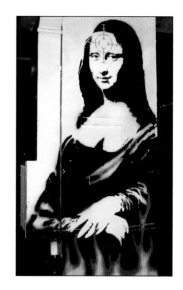

All Swiss Embassy photos by RomanyWG

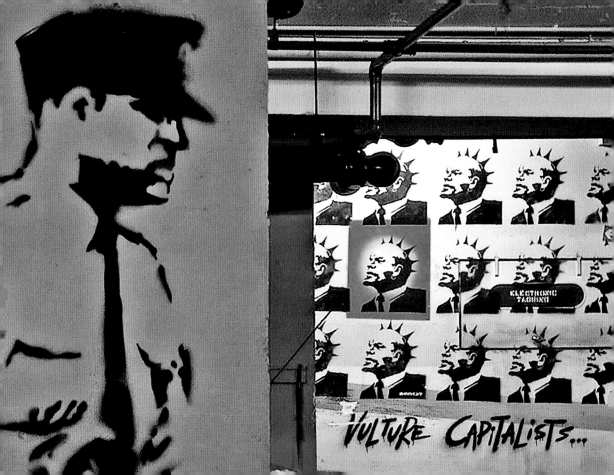

VULTURE CAPITALISTS...

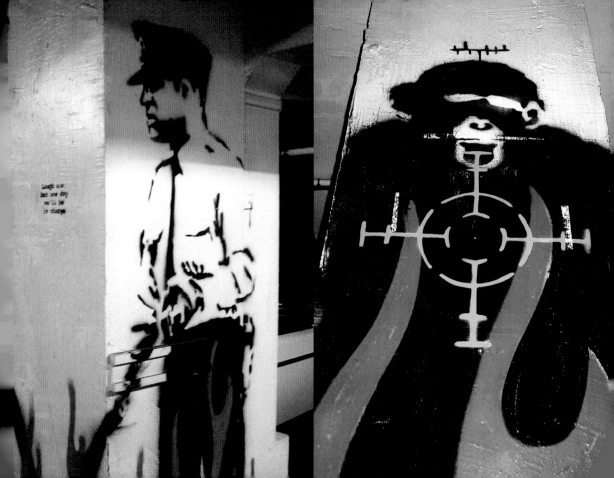

Laugh now
but one day
we'll be
in charge

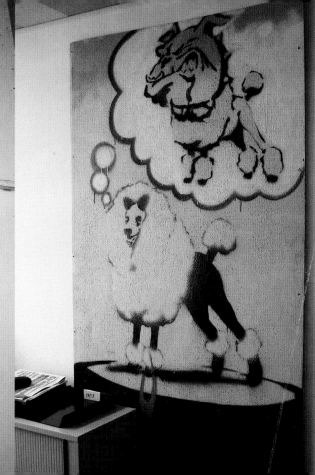

This is not
a photo
opportunity

LDN4

Banksy Tags

We may never know if they are real or not, but two Banksy tags exist in the avant-garde arty venue of the old Horse Hospital near Russell Square (WC1N 1HX). The manager of the building told a friend that they had been done in about 2000 and that they had appeared at the same time as a couple of stencilled images outside. Well, I know for sure there was a lovely large riot copper next to The Friend at Hand pub on Herbrand St, so the story might actually be true.

POISON RAT

This was on the back of a bright red bus ticket machine on Hampstead Rd, very close to the large junction with Euston Rd (Euston Underpass). It was the best quality poison rat I had ever seen, although it didn't have any toxic waste spilling from it. It had been there since at least mid-2006 but was painted over sometime in 2008, to send it to the pet cemetery.

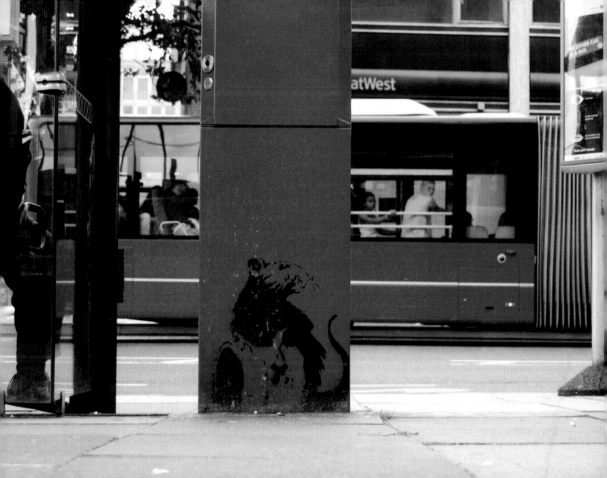

LDN5

CND SOLDIERS & PETROLHEAD CANVASSES

For a few years these two large canvasses were part of Brian Haw's peace and anti-sanctions camp in Parliament Square, London, after apparently being donated to the cause by Banksy. The CND Soldiers canvas was basically the same as the street version shown towards the front of the *Cut It Out* and *Wall and Piece* books, and also the print version sold via Pictures On Walls (POW). Peace advocates often poignantly placed little wooden crosses at the bottom of the canvas.

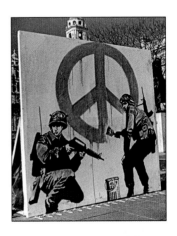

The other canvas was commonly known as Petrolhead, as it showed a man pointing a petrol pump at his head like a gun (it can briefly be seen in *Cut It Out*). The first one of these was apparently stolen and was replaced with the one in my photograph. A 10cm square sticker of it used to be available via POW with the 'catalogue number' BNK/5Y 027, a small canvas of it was on sale at Santa's Ghetto in 2003, and the image also appeared twice at the Turf War exhibition in July 2003. In addition this image was stamped on a rare 12" white-label sampler for Blur's *Think Tank* album in 2003 and also on a promo CD. Placards of it were also made for the anti-war protests in London in February 2003.

One night in May 2006 Brian Haw was visited by police officers (one source wrote that 78 officers took part), who had been given the twisted authority to reduce his protest to merely three metres wide. The inset photo shows the after-effects. These canvasses, and many other banners and protest paraphernalia, were confiscated by the police who allegedly never returned them to the owner. No one seems to be able to confirm what happened to the canvasses. Rumours point to their destruction, or maybe lying somewhere in police storage.

In 2007 the original peace protest was rather strangely 'recreated' by the artist Mark Wallinger and shown in the Tate Britain gallery. Even more strangely, this assemblage actually won the Turner Prize for 2007, which included a cheque for £25,000!

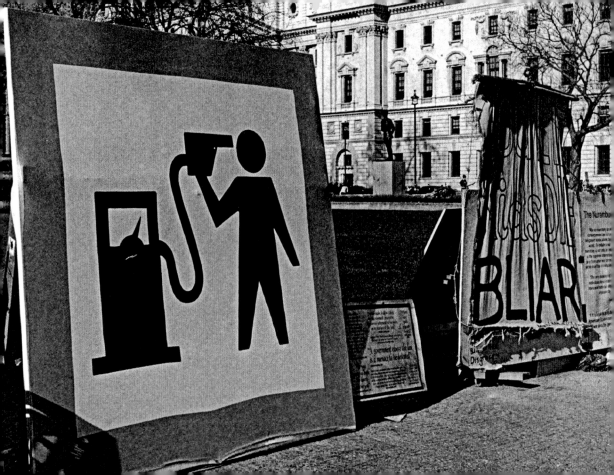

LDN6

WHAT?

This appeared in late May 2006 on the back of what seems like
an almost permanent street stall that sells T-shirts and bags on
Tottenham Court Rd, near the junction with Store St. A photo of it
was added into the paperback version of Banksy's book *Wall and
Piece* and was one of four uses of the same image around this time
(see Location S25 in *Banksy Locations & Tours Vol 1* for another). It
has also featured on his website and in the *B Movie* special feature
on the *Exit Through the Gift Shop* DVD.

By the end of June it had been removed with permission from Sam
Khan, the 60-year-old stall owner who had never heard of Banksy
before, and was sold to someone for a reported £1,000 in cash. Not
long after, a bit of a tiff broke out as the stall owner didn't seem to be
so happy now that there was a lot of press coverage on it and that it
had almost immediately gone on sale via Bankrobber Gallery, with a
minimum price of £230,000. I later saw it on display/for sale at the
Gallery in Lonsdale Rd, just off Portobello Market, in March 2007.
Bankrobber were the same people who helped with the appallingly
entitled Banksy Does New York exhibition at the Vanina Holasek
Gallery in New York in December 2007.

In 2009 it seemed that we got some clarity about Vermin, as their
website stated that "From 2009 Vermin recognizes Bankrobber as
the only commercial outlet for Vermin-certified works" and several
street pieces were being openly offered for sale by Bankrobber.

By spring 2008 the piece could be seen in the lobby of an office
building at 55 Newman St, W1T 3EB; opposite 'Basler' and close to
Goodge St (see inset photo). It seems rather ironic that a Banksy
street piece should end up in a building used by an advertising
agency formerly known as Banks Hoggins O'Shea/FCB. It seems to
be a permanent fixture because it was still there when I looked in
January 2011.

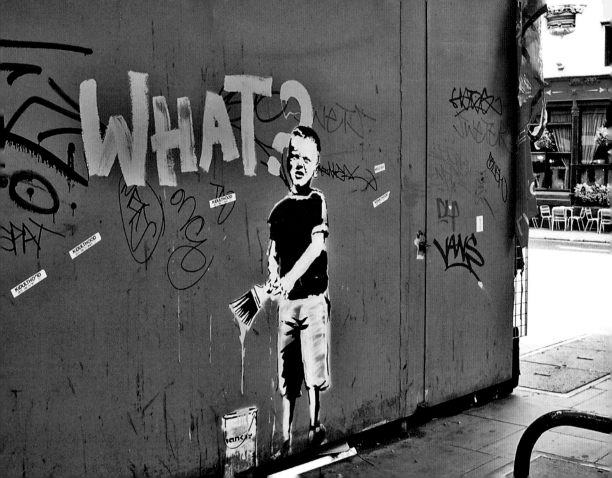

ONE NATION UNDER CCTV

Surely one of Banksy's most amazing and ambitious pieces. Although the wall was actually the side of the building occupied by the First Colour Print Centre at 15 Newman St (W1T 1PA), access to it is from behind the large railings of the Post Office distribution centre next to it.

Like most newer Banksy pieces scaffolding was erected so a proper job could be done. The story goes that some company nagged the Post Office to let them put up some scaffolding on the wall in order to do some urgent work. Eventually they agreed, and on Sunday 13th April 2008 the scaffolding came down after six days up, revealing the work. Now that's what I call cunning!

It rapidly became a topic of interest worldwide and as it was just off Oxford St it also rapidly gained a huge number of visitors; so many in fact that the Post Office thought it was a hazard to their delivery lorries (and the rubberneckers).

In October 2008 Westminster City Council's planning sub-committee agreed that it should be removed and Robert Davis, Deputy Leader of Westminster City Council, was quoted as saying, "We are not saying the owners need to paint over this mural as we can see it has value in the right location, such as an art gallery. We simply want it removed from this wall and the owner is perfectly entitled to remove it and sell it if they wish. I take the view that this is graffiti and if you condone this then what is the difference between this and all the other graffiti you see scrawled across the city? If you condone this then you condone graffiti all over London." The Council website's general info on graffiti says that "Graffiti and fly-posting are illegal, anti-social activities that create a negative impression of an area and contribute to people's fear of crime."

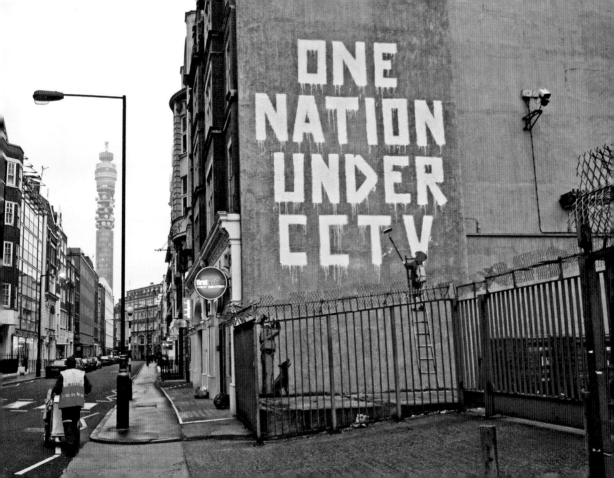

It obviously wasn't clear who 'owned' or was responsible for the wall because a property investment firm called Searchgrade and the Royal Mail were both reported as claiming it as 'theirs'.

As a consequence nothing happened until 6th March 2009 when scaffolding suddenly covered it. A spokesman for Royal Mail was quoted by the BBC as saying they did not want to cover the work, but "Unfortunately, Westminster Council have told us that we must either remove or cover up the mural. We are having to do this simply because we have been told to."

By 12th March it had been 'greywashed' although ironically it could just still be seen underneath, as if they couldn't afford two coats of paint. In April 2009 a thicker coat was added.

A photo of it was briefly featured in Banksy's film *Exit Through the Gift Shop*.

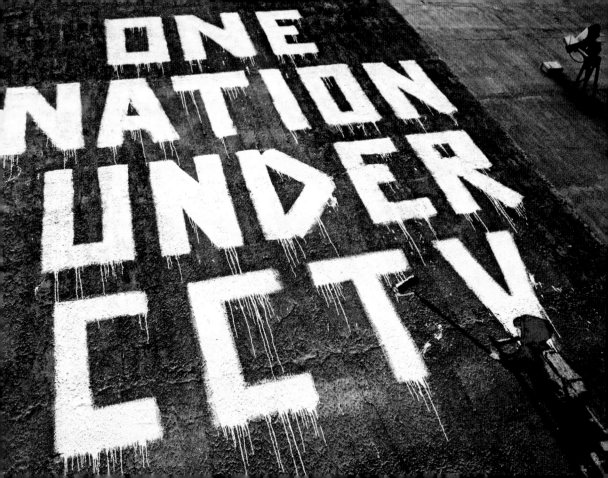

LDN8

IF GRAFFITI CHANGED ANYTHING – IT WOULD BE ILLEGAL

Postcode: W1W 5DQ
Map/GPS reference: TQ 29117 81924
Location: On the corner of Clipstone St and Cleveland St, in Fitzrovia.
It's bang next door next to the BT Tower (a.k.a. the Post Office
Tower to our older readers), which despite being built in the early
1960s, having a viewing platform for tourists and a famous 'revolving
restaurant' at the top, remained officially 'secret' until 13th February
1993 when the government finally announced that they could admit it
existed and would now be added to Ordnance Survey maps.

This was done on Easter Monday, 28th April 2011, with a local
worker saying he saw 'them' doing it at 3 a.m. I like the rat 'signing'
it with his paw print. Nice touch. As it appeared just before the
May 2011 elections (and the Referendum on the voting system) it's
presumably a take on Emma Goldman's old anarchist slogan 'If voting
changed anything, they'd make it illegal'. Goldman was once called
'the most dangerous woman in America'. That accolade later more
fittingly passed to Condoleezza Rice.

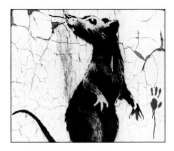

Within a week Westminster Council's 'No Graffiti' policy resurfaced,
with a spokesman saying: "Officers have inspected the graffiti and,
as it is on property owned by the council, it will be removed... As a
council, we can't on the one hand crack down on someone daubing a
wall with a spray can, while letting famous names get away with it."

However, it was covered in transparent plastic on 5th May (see
photo). Which raises the question, who did that, given it's a Council
wall?

Nearest tube: Great Portland Street (Hammersmith & City, Circle,
and Metropolitan lines) or Warren Street (Northern and Victoria lines).

Status

Covered in plastic, awaiting possible buffing? (May 2011).

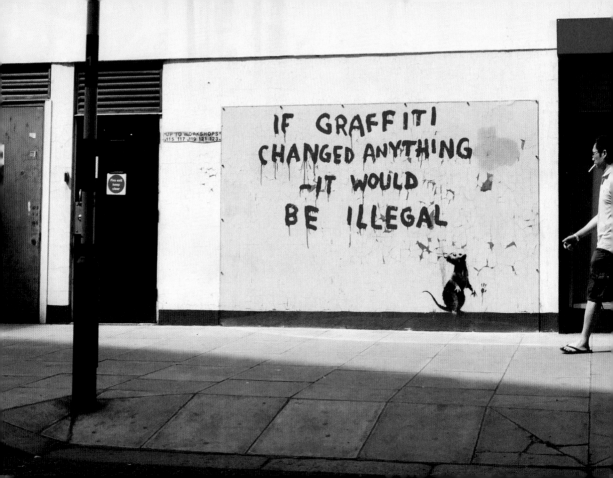

LDN9

SPERM ALARM

The first the world heard about this was when a photo of it was added to Banksy's website on 14th January 2011, labelling it as 'Sperm Alarm'. Despite the photo offering few location clues it was tracked down before the day was out, to the Home Office Identity & Passport Service building by the side of Victoria Station (Bridge Place, SW1V 1AF. Map/GPS reference: TQ 28994 78857).

It had a little bit of overspray and drips, and used the existing fire alarm. A CCTV camera above it seemed to be no deterrent.

I went to visit it on 12th February and my curse struck again (see Location B&L4). The fire alarm had been taken and the sperm had been cut off the wall (it was a thin-ish metal sheet). I tried to 'converse' with the security guard there but his English was so limited (in the passport office – huh?) that I'm not really sure what he was saying. He seemed to suggest it had gone 10 minutes before I got there, which would mean it was done in broad daylight on Saturday lunchtime on his shift! I would suggest it was actually probably taken on Friday night/Saturday morning.

Within a few days it was being offered for sale on eBay. The seller wrote that he had permission to take it, and that "Banksy work can sell for up to £1 million at auction", but thankfully it never even staggered past the £17k opening price.

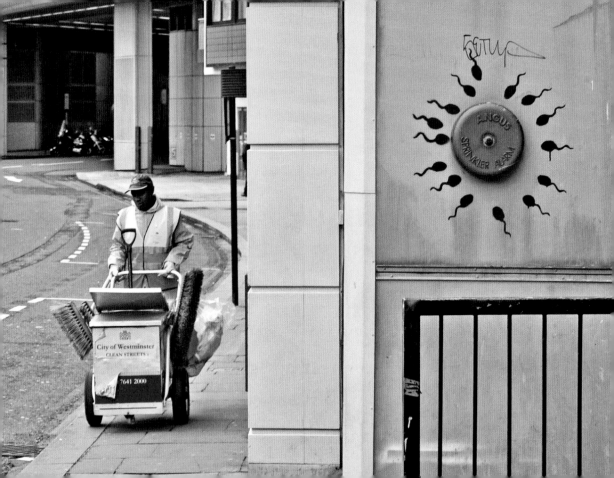

LDN10

DRILLING RAT

For many years this great drilling rat was happily doing its thang, drilling into a cracked open electricity box. I particularly liked the dainty radio headset it had on.

It was there in Crondall St, Hoxton (postcode: N1 6PJ. Map/GPS reference: TQ 33236 83113) from at least early 2005 but the electricity box was replaced sometime between May and September 2010 and the rat was buffed.

This exact one is not featured in any of Banksy's books but the drilling rat image is in his books (e.g. *Wall and Piece*), and the quality of this one, alongside its Hoxton location and excellent placement would lead me to assume it was genuine.

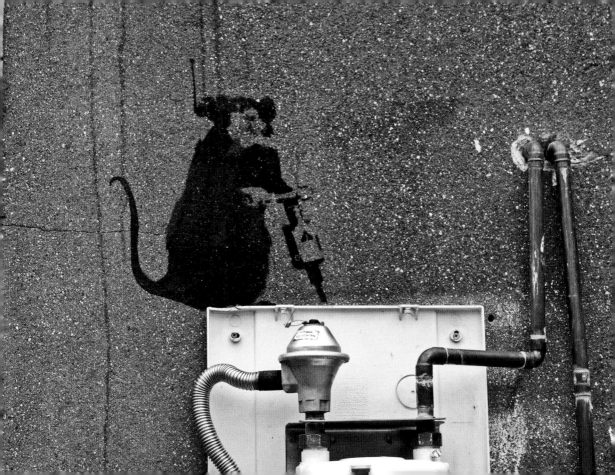

LDN11

BUBBLE GIRL

This was on the south side of Lower Clapton Rd (A107) near the junction with Urswick Rd (A102). The first time I definitely know it was spotted was on Wednesday 27th February 2008 by people on their daily bus commute to work, so it was probably done very shortly before that. It made great use of the drainpipe and brightened up the skanky building and filthy alcove next to it.

It was buffed in December 2008, presumably because it was on the side wall of a previously disused art deco-ish South Eastern Electricity showroom, the Strand Building, that had been converted back into use as the Levy Centre by architects Barker Shorten. The Levy Centre at 18–24 Lower Clapton Rd, E5 0PD, was opened by the charity Community Service Volunteers (CSV) as an educational centre for the community of Hackney. Michael ('Lord') Levy had been thanked for his support to CSV at a surprise gathering at the building on Monday 25th February 2008 and was joined there by CSV Celebrity Ambassador Pete Waterman. Yet more hard proof that Pete Waterman really is Banksy.

Two other new pieces were first spotted on Monday 25th February 2008: 'Take This – Society!' at Location LDN20, and the Fisher Boy at Bermondsey Wall West, so presumably Banksy was very industrious in London those few days.

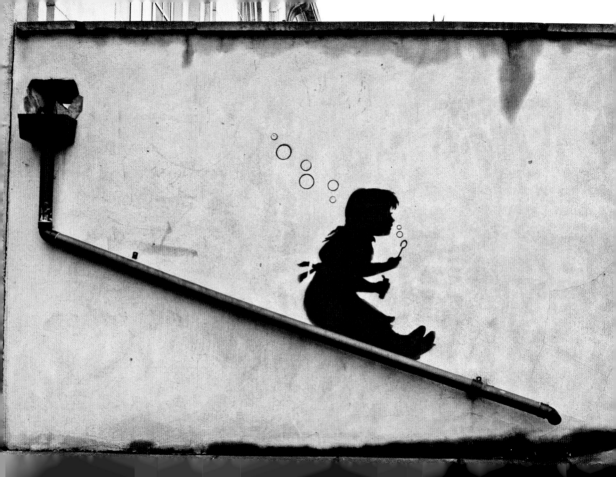

B BOY

This was first spotted in Gillett Square, Dalston, a tiny created square between Bradbury St and Gillett ST, just off the A10 Kingsland High St, on Saturday 28th February 2009 and is assumed to have been done earlier that day. One local street cleaner said that he saw the piece being done by three people at about 7 a.m., under a tarpaulin. Another report described it as like one of those BT work tents. On that day a friend of mine said that he had heard about it but was not near enough the area to take a look. I could easily top that as I was over 300 miles away in Carlisle watching the Gas (Bristol Rovers F.C.). It was my first time there, and my 55th League ground. Although Banksy and several other Bristol writers seem to be City fans, I'm sure they will one day see the light. Roni Size is a Gashead, so we narrowly win on celeb points, I reckon.

Anyway, I digress... as usual. I like the way the ventilation grille/ brick is used as the speaker of the ghetto blaster and the 'lino' on the floor is actually sprayed on and reminds me of the lino or cardboard the B-Boys used to take to the local shopping precinct on a Saturday morning during the breakdance craze of the early(ish) 80s. I also wonder if this piece is a response to the history of this site? Banksy did a gas mask girl here many years ago but it was buffed 'by accident' in 2007 when they created this cultural area. Oh the irony of it all.

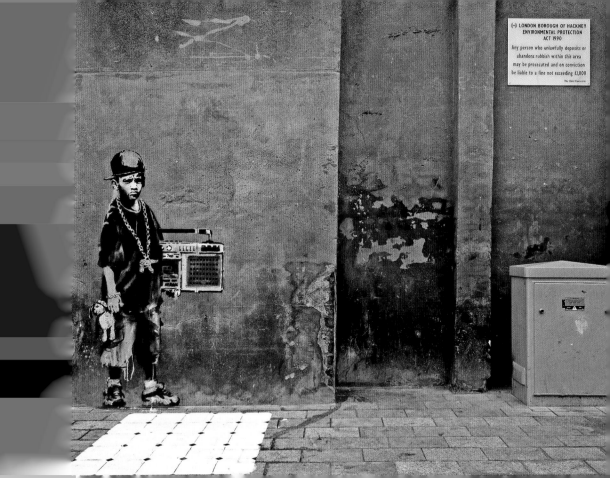

LONDON BOROUGH OF HACKNEY
ENVIRONMENTAL PROTECTION
ACT 1990

Any person who unlawfully deposits or
abandons rubbish within this area
may be prosecuted and on conviction
be liable to a fine not exceeding £1,000

The Chief Executive

Within the week Hackney Council said it would buff it. Alan Laing, Hackney's Cabinet member for neighbourhoods, is quoted as saying: "Our position is not to make a judgment call on whether graffiti is art or not, our task is to keep Hackney's streets clean." The community organisation which holds the leasehold of the building, Hackney Co-operative Developments, didn't want that to happen and their director Adam Hart is quoted as saying, "I am shocked to hear of such an unpopular and unnecessary act of vandalism against a valuable work of art. Banksy is something of a folk hero." They apparently then negotiated a stay of execution for the piece pending an application for the wall to be a designated graffiti area but it mattered little because around the 5th March it was seriously defaced with the slogan 'Love Not Money' (see the photo opposite). Within days some local people tried to restore it a bit and then the writer '10foot' badly dogged it with the same 'Say No To Art Fags. R.I.P. Ozone' message as on The Old Street Cherub (see Location S12 in *BLT Vol 1*). By mid-April 2009 it was totally buffed.

A pencil sketch of this could be seen as part of the myriad of images in the mock-up of Banksy's studio at the Banksy vs. Bristol Museum exhibition in June to August 2009. A photo of the piece after it was dogged was also there: Banksy definitely has a sense of humour.

After a strong period of street activity in London, including Locations LDN17, LDN19, and LDN25, Banksy's website was updated on 25th September 2009 and for the first time a photo of this piece was included.

In October 2010 his website suddenly included the whole history of this piece, from a photo of the wall when blank, through original sketches for the piece, and on to photos of it clean, and then trashed.

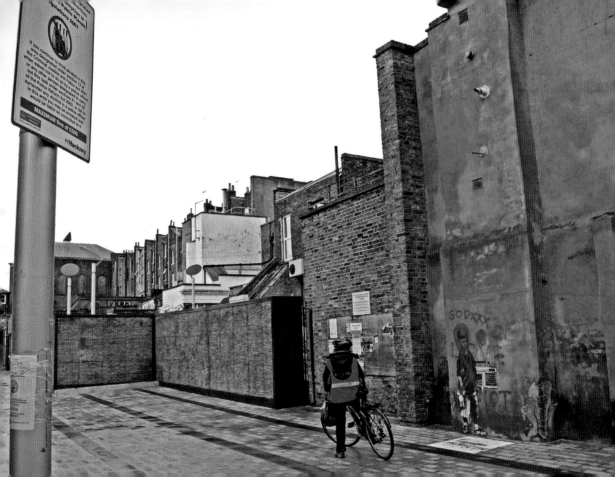

LDN13

KILL PEOPLE

Possibly the happiest of all Banksy graffiti?

Well, certainly this was one of the hardest to locate and get to, because although it could just be seen from the canal towpath of the River Lee Navigation in remote Hackney Wick (just to the side of the road/canal bridge on White Post Lane), to get a close-up photo you had to walk through the Queens Yard business area and hop over the fence by that side of the canal (postcode: E9 5EN/TQ 37260 84535).

This piece can be seen in his books *Cut It Out* and *Wall and Piece*, although not prominently. Do I suspect he thinks this might not be such a crowd-pleaser? It may well date from 2003, as at least five other very similar versions were done that year, albeit mainly with different messages spelt out by the building blocks: at the Turf War exhibition (spelling out 'Kill More'); in the Revolver bar in Melbourne, Australia (expressing 'Thug Loving'); two at the Semi-Permanent Graffiti and Street Art Exhibition in Sydney, Australia (asserting 'Obey Banksy' and 'Kill People'); and, at the Banksy vs. Eine exhibition in Copenhagen, Denmark (declaring 'Self Harm').

So this was probably the most remote location of a Banksy in London; but not a total surprise as a huge colony of artists have studios in this area, previously including a certain Mr. B. In mid-2007 two typically large Cyclops and Sweet Toof pieces were put up surprisingly close to it. They regularly hit this area in 2007 and 2008, but obviously caused some controversy this time as the larger one later had 'painted by scum' written on it! In mid-March 2009 the *Hackney Gazette* reported that a gang of people with industrial cutting gear had indeed been disturbed by artists from the nearby Elevator Gallery; who now wanted it preserved. No-one was quick enough, though, as it was whitewashed by the end of March. In a strange way maybe it was someone kind of 'protecting' it from being stolen, and from the inane debates about 'saving' street work.

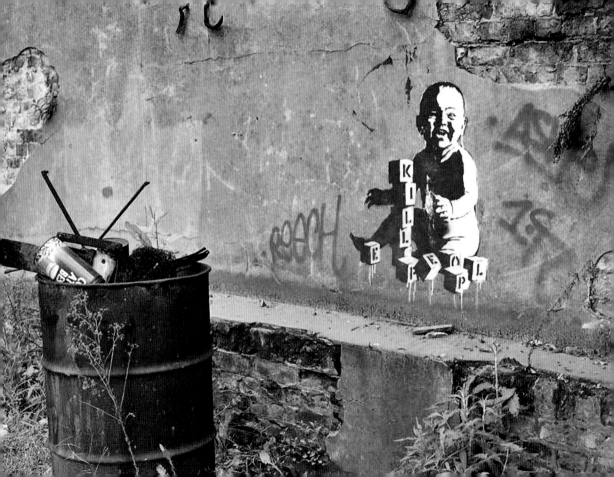

LDN14

ARTISTE/BLUE PERIOD
Postcode: E9 7HD
Map/GPS reference: TQ 35795 83953
Location: Shafton Rd, Hackney, on the corner with Victoria Park Rd
(A106)

This was done in late August 2007, on the side of a Vietnamese
restaurant called Namo at 178 Victoria Park Rd, London, E9 7HD.
It's a remake of the one at Portobello Market. In May 2007 an
image similar to this was sent to an American journalist who was
doing an article for the *New Yorker* magazine. A photo of it on
Banksy's website calls it 'Nob Artiste' but I have also seen it labelled
elsewhere as 'Blue Period'. A $ signed ball and chain was added to
it by a person unknown in early February 2008. This echoed similar
additions made to the 'Flower' (Location LDN15) around this time.

In April 2008 the Hackney Graffiti Removal Unit partly 'cleaned'
it up by loosely painting over the giant graffiti-style phallus and the
tags around it, although presumably the latter had actually been done
deliberately by Mr. B to recreate a graffitied wall! This shouldn't be a
total surprise as this Council had removed Banksy's work before (see
the history of Location LDN12) and because graffiti policies generally
state that 'offensive graffiti' should be removed ASAP. In May 2010
a Rolling Stones logo was added next to it, alongside a speech
box proclaiming 'Viva La Robbo'. This was presumably part of the
longer-term fallout from the infamous 'Robbo incident' (see Location
LDN29). The piece was dogged twice in August and September 2010.
In March 2011 the wall behind the piece was carefully painted grey
again, but the dogging on the painter was deliberately left alone.

Status
Not looking too bad now (March 2011) although obviously not
'restored' to perfection.

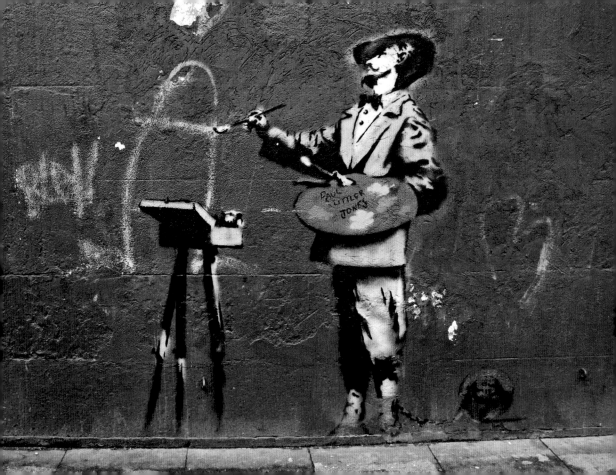

FLOWER
Postcode: E2 6NB
Map/GPS reference: TQ 34416 82802
Location: On the corner of Pollard Street and Pollard Row, Bethnal Green.

It's actually on the side wall of the Bethnal Green Workingmen's Club at 44–46 Pollard Row. This was most probably done on Sunday 28th October 2007 as it was first spotted and reported on the following Monday. A website published photos of scaffolding and tarpaulin around the site with 'Banksy' (i.e. some bloke!) doing it. It is believed that the Workingmen's Club had been approached beforehand and gave permission for it to be done.

Not long after, the Council removed the double yellow lines running across the pavement, which was not totally surprising, I guess, as that is the only bit they were allowed to remove. But it does take away the coherence of the piece because without that it's no longer obvious that the worker has been painting the double yellow lines on the road and then decided to continue over the pavement and up the wall, finally drawing a pretty yellow flower. The piece is called 'Flower' on Banksy's website.

Only a week earlier the Labour Party-run Tower Hamlets Council had made a statement that "Tower Hamlets Council takes the cleanliness of the borough very seriously and is committed to removing all graffiti as soon as possible... we need to be clear here, graffiti is a crime." Within a week of the Banksy going up the Lib Dems were making a point about how good it is. Who said politicians were shameless vote-grabbers?

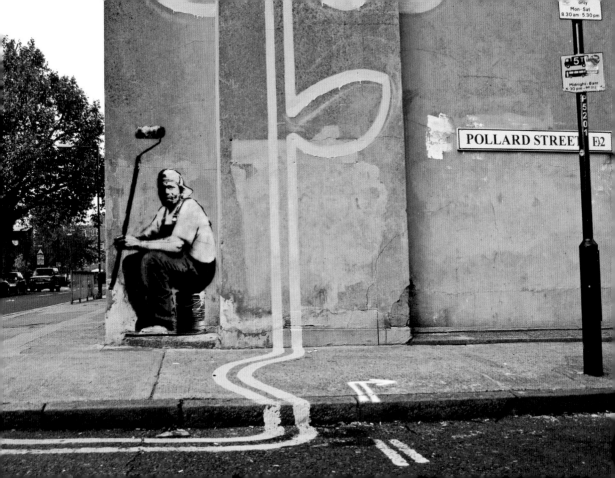

Since then all sorts of other additions have gone up around it (plus some dogging), with notable mentions to a stencil with a Council logo reading 'Commissioned By Tower Hamlets', a pair of gold trainers that were added by a person unknown, and most recently a comment that reads 'Vandals found vandalising this vandalism will be prosecuted'. The painter's face has badly worn away and a lump of brick has been dug out of the wall, but other than that it's in pretty good condition.

A photo of it whilst dogged is used in the *B Movie* added extra that was part of the *Exit Through the Gift Shop* DVD release in 2010.

Nearest tube: Bethnal Green Train Station (trains operate via Liverpool Street) and Bethnal Green tube station (Central line) are pretty much equidistant from the graffiti.

Status
It's still OK-ish, as described above (May 2011).

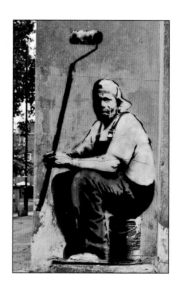

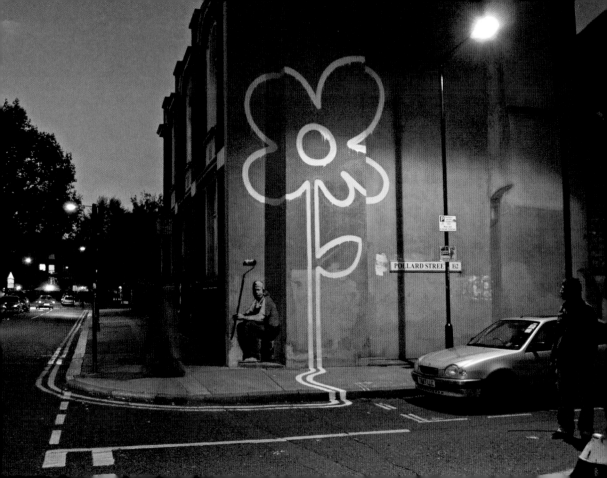

LDN16

CRAZY BEAT

Postcode: N16 0UD
Map/GPS reference: TQ 33210 86528
Location: Stoke Newington Church St, London. On the south side of
the street opposite the junction with Lordship Rd.

I'm not sure if this is really called Crazy Beat but everyone calls it
that because it is the cover artwork that Banksy did for Blur's July
2003 single called, yes, you guessed it, 'Crazy Beat'. It was used for
the CD single. The 7" had a similar but different image and buying a
copy of the 7" single is a very good way to get a cheap Banksy to put
on your wall! Property owner Sofie Attrill apparently gave consent
for the mural to be painted so it could be photographed for the
single's launch. It was later featured in Banksy's book *Wall and Piece*.
It has been there since at least early 2004.

 On 27th August 2009 Hackney Council painted over a considerable
portion of the piece before Sofie Attril could run over to tell them
to stop. The *Hackney Gazette* reported that the council said it had
sent three letters to Ms Attrill asking her to cover up or remove
the graffiti. The BBC later quoted Hackney Councillor Alan Laing as
explaining that "Due to a problem at the land registry unfortunately
our letters stating our intention to clean this building didn't reach
the owner. As soon as we realised this, work stopped. We are now
speaking with her about how to resolve the issue."

Status

Pretty much fine until the Council 'vandalism' in late August 2009.
The top section had never had any problems anyway, although tags
or throw-ups often existed on the lower section. After the Council
blackwash the crucial main section of the characters and the balcony
mainly remained (see inset photo, below right, from January 2010). But
if you know what it originally looked like it does look a little strange now.

LDN17

NO BALL GAMES

Postcode: N15 4BN

Map/GPS reference: TQ 33793 89518

Location: On the side of 'Biuro Rachunkowe', a Polish accountants office at 328 Tottenham High Rd (A10) in North London. The building is directly opposite the junction with Philip Lane (B153). From Seven Sisters station, come out of Exit 2 and walk straight up that side of High Rd. Just after the artwork there is a Chinese take away called Happiness – that made me smile.

It seems clear that this was done during the night of Saturday 19th or the early morning of Sunday 20th September 2009, using the old blue tarpaulin method. Photos of it and its location didn't however emerge until Tuesday 22nd which is strangely slow given that most are on the internet within hours these days, and that over that weekend there had been rumours that there was 'another Banksy' somewhere in East London (see Location LDN25 for the other Banksy that emerged that weekend). By Friday 26th it was covered with a sheet of transparent plastic (see the inset photo). I couldn't get there fast enough to capture it *au naturale*.

It's based on a image used before in the studio, although IMO the street piece has a better version of the young boy. The first known version of it was done for the Barely Legal exhibition in Los Angeles in September 2006 and instead of 'No Ball Games' it has a TV with a ball inside it. In 2008 a very similar version was done on a metal sheet. It was sold at an 'Urban Art Sale' in Feb 2009 for £28,000 and was described in the catalogue as "unique in this format". A canvas using the 'No Ball Games' bit was later included in the Banksy vs. Bristol Museum show in summer 2009. Finally, in December 2009 a screenprint version came out in two editions, green and grey, via Pictures On Walls. Using a 'No Ball Games' sign is not new for Banksy; see Location WL8.

In mid-October 2010 'Team Robbo' amended the sign (on top of the plastic) to read 'Banksy Has No Balls'. See Location LDN29 later for the low-down on how this beef started.

Status

Still excellent (May 2011), despite being covered in plastic and the slogan having suffered after the Robbo amendment.

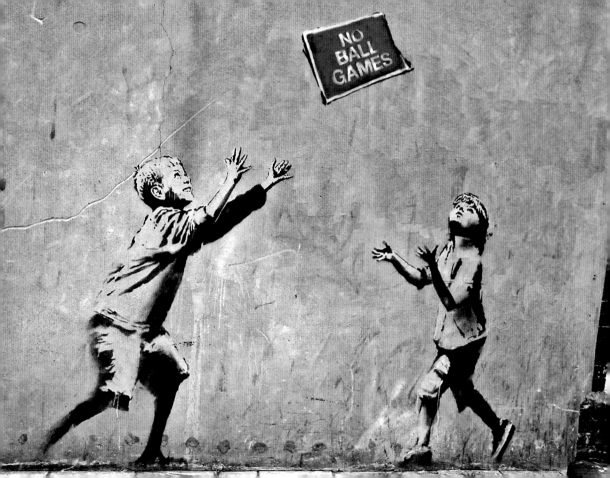

LDN18

THE BEAR & THE BEE

This piece probably dated from 2005 as it was the same as the one on Kensington Park Rd in Notting Hill that was dated to 2005 in *Wall and Piece*. That one was buffed circa December 2006, whereas this one lasted longer.

It was located alongside a mish-mash of other graffiti on some rather photogenic metal doors along the Grand Union Canal (Paddington branch) towpath in Kensal Town, between Great Western Rd and Ladbroke Grove.

Around the end of 2005 the doors were repainted, but the poem was carefully painted around. The painting does mean that it is quite difficult to read, though, so I've transcribed it for my dear readers: "Once upon a time there was a bear and a bee who lived in a wood and were the best of friends. All summer long the bee collected nectar from morning to night while the bear lay on his back basking in the long grass. When Winter came the Bear realised he had nothing to eat and thought to himself 'I hope that busy little Bee will share some of his honey with me'. But the Bee was nowhere to be found – he had died of a stress induced coronary disease."

The text is presumably a parody of one of Jean de La Fontaine's most famous fables, 'La Cigale et la Fourmi' ('The Cicada and the Ant'). La Fontaine was a 17th century French poet and fabulist. The full poem, including a translation, can be found on the 'net, at www.jdlf.com/lesfables/livrei/lacigaleetlafourmi

Once upon a time there was a Bear and a Bee who lived in a wood and were the best of friends. All summer long the Bee collected nectar from morning to night while the Bear lay on his back basking in the long grass.

When Winter came the Bear realised he had nothing to eat and thought to himself "I hope that busy little Bee will share some of his honey with me". But the Bee was nowhere to be found – he had died of a stress induced coronary disease –

LDN19

ROLLER ZORRO

This was on the roof of what was the Great Western Studios (www. greatwesternstudios.com), before it moved. The building is just off Great Western Rd. It's the old bus garage that is sandwiched between the elevated Westway (A40) and the train line (postcode: W9 3PD).

It was first spotted on Monday 24th August 2009, so it was probably done on the previous Sunday. It said 'Live Fast Drive Slow' on the other side of the roof turret (see photo right) and there were splodges of pink paint on the other turret as well; all in that almost trademark shade of pink that has been used so many times before.

The image was pretty ginormous, about four or five metres I would estimate, and it nicely used the centre circle that was there before (it used to say 'Great Western Studios') as if it was a moon. It also wasn't afraid to use the recessed window.

It seems to be similar to a piece that Banksy had used before: a sort of Zorro character with a paint roller. Close up photos make it look more like a highwayman (which could make sense as West London was a highwayman haunt), but apparently it is definitely based on Zorro.

In early September 2009 a written addition was made to the other rooftop turret. It mysteriously read 'Take This as a Sign' in large black rollered letters. On 3rd November 2009 scaffolding was seen around the towers and over the next few days it was 'collected' (i.e. taken away!) and replaced with large sections of blank wood cladding. Photos on the internet show the piece neatly stacked in storage afterwards. Hmmm... strange end to the story.

Photos of it were never added to his website but I was always of the feeling that no-one else could have done this. In September 2010 we finally got cast-iron 'confirmation' that Banksy did this, as footage of it being made, and going up, were included in the *B Movie* added extra that was part of the *Exit Through the Gift Shop* DVD release.

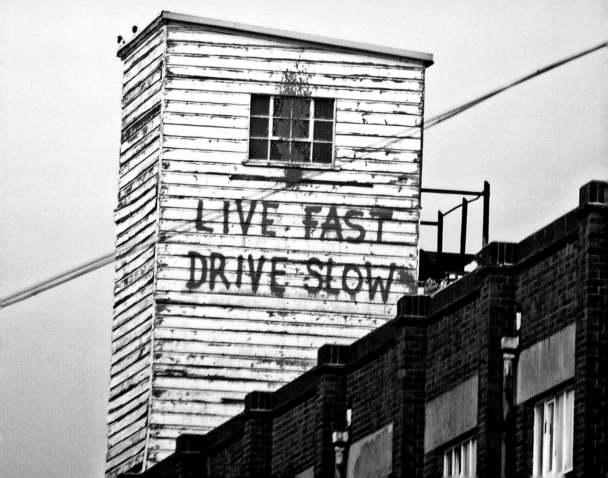

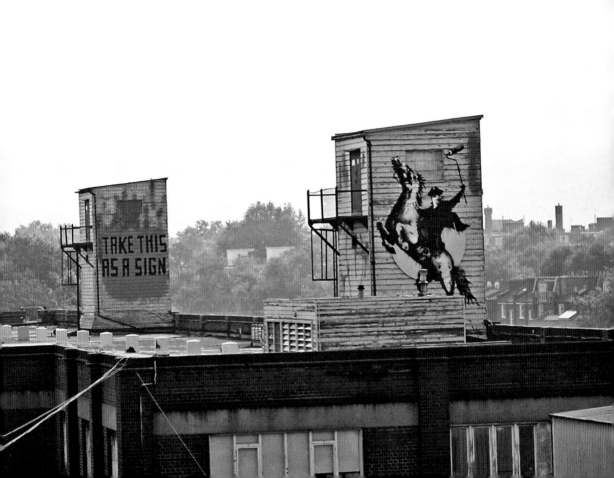

LDN20

TAKE THIS – SOCIETY!

This was on a large concrete block in the middle of the massive Holland Park roundabout, where Holland Park Avenue (A402) and the West Cross Route (A3220) converge.

It was one of three new pieces that were first spotted on Monday 25th February 2008, so presumably Banksy was very busy in London the weekend before. The others were the Bubble Girl at Location LDN11 and the Fisher Boy on Bermondsey Wall West.

It was whitewashed on 8th March 2008 before I could even get to London to get photos of it, so I've borrowed one off my mate Dave, and added my own 'context shot' of it after buffing. The Banksy piece was on the grey wall, behind the cones.

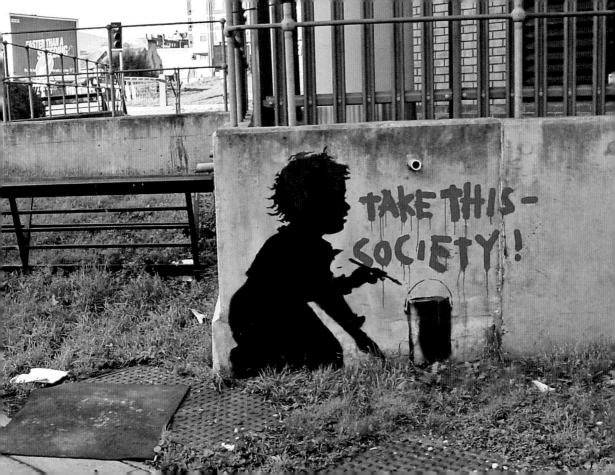

BASKETBALL RAT ['NO BALL GAMES']

Q: What three words unite communities all over Britain?

A: No Ball Games

One of my favourite Banksy pieces, as the placement was perfect and I loved the attention to detail in giving the rat proper basketball-style trainers. This was in a private street called Gloucester Gardens, just off Bishops Bridge Rd, for several years although I bet they also have a pretty identical sign in the high-rise council estate a goal kick away across the busy main road. All over the UK we seem to have something against playing ball games. No wonder we are often rubbish at ball sports.

In mid-October 2006 it was one of the first Banksy pieces to suffer the ignominy of being stolen. The plaster was cut out with only the brick wall left behind. Local residents were outraged. David Hopwood, a resident on the street, was quoted as saying, "I complained to the police but they said as it wasn't a robbery or an assault, they couldn't help. Westminster Council was disinterested." Soon after it appeared on eBay with a starting price of £20,000, but enough people complained about it to get it removed from the site. I've heard no news about it since.

This exact graffiti is featured in Banksy's earlier book *Cut It Out*, as well as *Wall and Piece*, and a photo of it after being stolen, to illustrate what is happening to street work, is used in the *B Movie* special feature on the *Exit Through the Gift Shop* DVD.

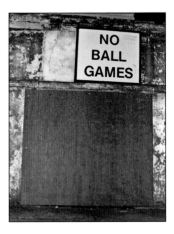

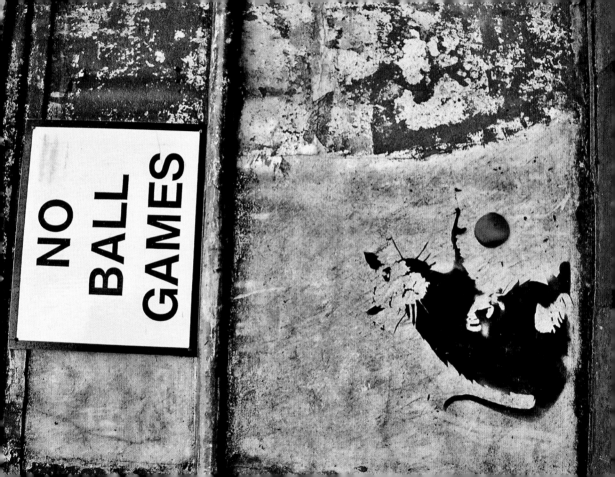

LDN22

GRAFFITI REMOVAL HOTLINE

This popped up overnight on the 20th–21st May 2006 on Talgarth Rd West (the A4), where North End Rd crosses the A4 and almost lived up to its subject as it barely lasted a few weeks before it was rudely blacked out, probably in the evening/night of 10th June. Rumours at the time suggested that an irate local resident did it.

It was similar to the one near Angel, see Location LDN30, but this one had a stickman instead of the boy stencil and it had a much better surface to work with. Both of these pieces were on seriously busy main roads and it seemed to mark a turning point of even bigger and bolder pieces by Banksy. Very rarely would Banksy ever again bother to do small pieces or ones that weren't in high-profile spots.

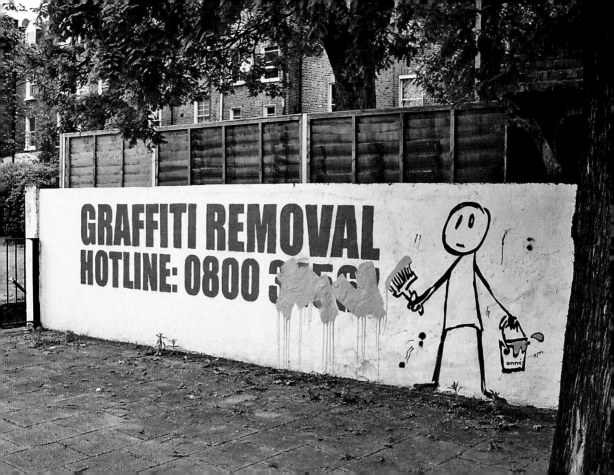

LDN23

CANS FESTIVAL / LEAKE STREET TUNNEL

The Cans Festival was a free special event that took place in the now dis-used Leake St tunnel under Waterloo station (postcode: SE1 7NN, Map/GPS reference: TQ 30915 79755) on the May Bank Holiday weekend of the 3rd, 4th and 5th May 2008. Banksy and many other artists did loads of stencil-based work in the tunnel, and the public were invited to queue up and goggle at it. About 28,500 people did so, and 691 of them also brought their own stencils to have a go on the free wall at the end of the tunnel.

A *Daily Mail* reporter was there as it was being done (yes, rather unbelievable but true) and reported that a note from Banksy was on the entrance. It read, "Graffiti doesn't always spoil buildings. In fact, it's the only way to improve a lot of them. In the space of a few hours with a couple of hundred cans of paint, I'm hoping we can transform a dark, forgotten filth pit into an oasis of beautiful art – in a dark, forgotten filth pit."

Banksy's contributions were as follows, listed from the South Bank end of the tunnel to the Lower Marsh end: Homeless Venus (statue – in the road); David with Flak Jacket (statue – road); Children's Play Area (including the graffiti-tagged reverse-stencilled Leopard – mainly on the road); Roller Chimp (right hand side – RHS), CCTreeV (road); Buddha (RHS); Brew Period (statue – road); Cave Painting (RHS – this was later labelled 'Cans Buffer' on his website); and, Unknown Hoodie (RHS). These titles come from an official sheet some people got, labelled 'List of Artists' work'. Over time the last two mentioned were heavily dogged and added to by others.

The green paint pattern being applied by the Roller Chimp also covered a piano, several furniture pieces, and an old cut-up Volvo car in the nearby room setting so there is an assumption that Banksy did those as well. The old Bedford Ice Cream Van served as a 'graffiti reception' and was something we later got used to regularly turning

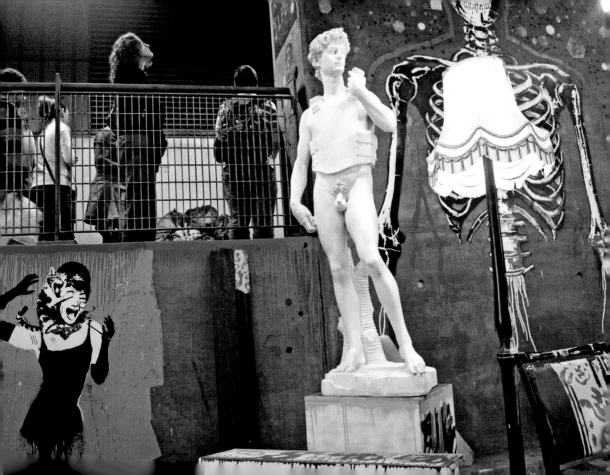

up at Banksy events, including the Glastonbury Festival in June 2008 and the Banksy vs. Bristol Museum exhibition in mid-2009. All three of the statues also turned up at the Bristol exhibition, albeit with changes.

Banksy's faded old snorting copper on the outside of the tunnel (see Location R6 in *Banksy Locations* & *Tours Vol 1*) still just about remained during the festival, but got surrounded by other graf, and was constantly photographed by people who seemed to think it was done for the May 2008 festival! By the way, this tunnel is the same tunnel that used to have Banksy's 'Monkey Detonator' piece in it (see Location R5 in *BLT Vol 1*) and it was also used in February 2010 for the pop-up cinema that showed his film *Exit Through the Gift Shop* and also showed some new installations and artworks.

Anything actually on the old road was removed after the festival closed but the wall-based ones were abandoned to their natural fate, usually slowly getting dogged until the end of August 2008 when the tunnel closed for a few days to 're-fresh' it, this time with mainly freehand work. Only a few pieces survived but they included Banksy's 'Roller Chimp', which could therefore be seen for a while longer. Quite soon after the whole tunnel became an unofficial Hall of Fame with a rapid turnover of pieces, so obviously nothing from Banksy survives now.

Photos of the Banksy pieces in the tunnel are shown here, in this order: 1: David with Flak Jacket (previous page – the photo also features art by Eelus and Paul Insect in the background); 2: Homeless Venus; 3: Children's Play Area (including the Leopard) – shown over four pages; 4: Roller Chimp (photo from after the August refresh – includes DAS and MauMau pieces to the right); 5: CCTreeV; 6: Buddha (also featuring art by Logan Hicks on the left, and Lex & Sten on the right); 7: Brew Period (Special Brew Statue); 8: Cave Painting a.k.a 'Cans Buffer'; 9: Unknown Hoodie.

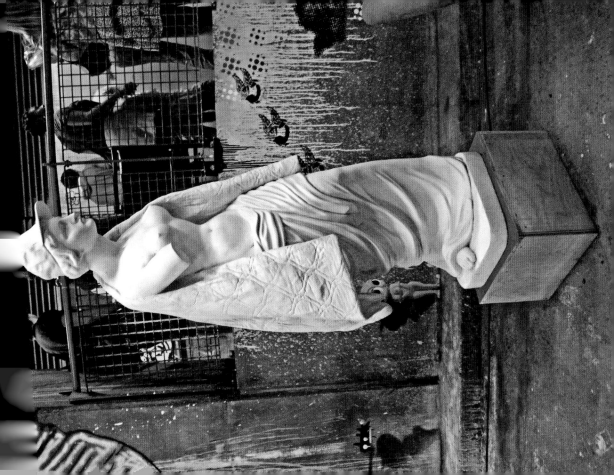

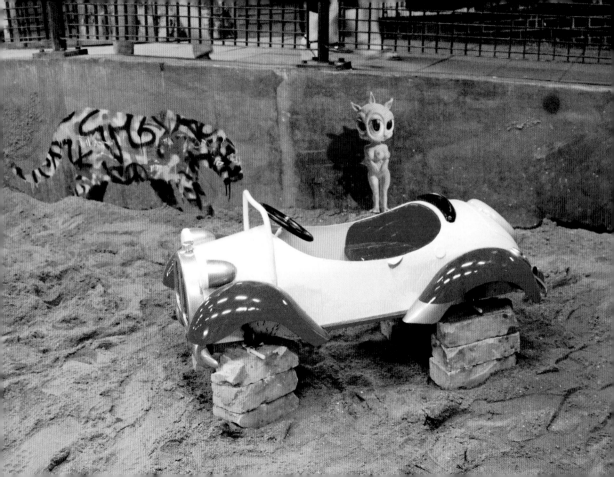

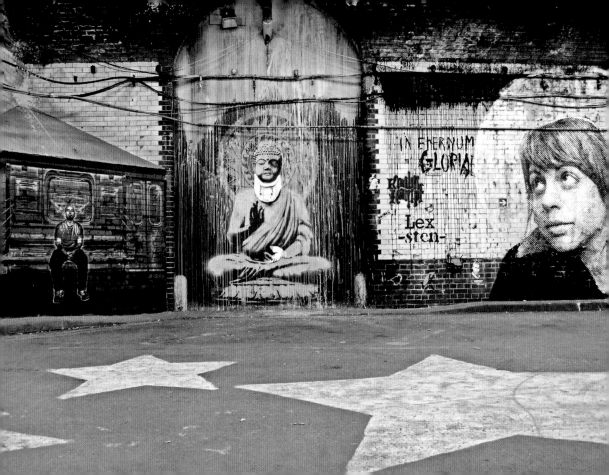

LDN24

HARING DOG & HOODIE OWNER
Postcode: SE1 3AD
Map/GPS reference: TQ 33577 79152
Location: The Grange, Bermondsey. On the junction with Grange Rd
(A2206).

This was first seen on the Wooster Collective website on 9th October
2010, which now seems to be the favoured publicity method for Banksy
to show fresh pieces. By the next day it had already been 'located' by
the eagle-eyed public and on the Monday a photo of it was added to
Banksy's website (labelled 'Haring Dog'). It was presumably done at
the same time as the 'London Calling' piece (see Location LDN27).

This was the first piece for a while to really leap out at me. The use
of a Keith Haring style dog was a stroke of genius IMO, and the thick
steel linked chain was also a sweet little touch. See www.haring.com
for more information about the highly influential but short-lived
1980s artist. The basic premise of the piece wasn't totally new for
Banksy though. In May 2010, he did an excellent piece in Toronto of
a security guard and a less than butch looking pink 'balloon dog' like
the ones that Jeff Koons creates.

I liked the placement as well because there is a massive
advertising hoarding above the piece, but out of shot. Within days the
wall, but not the piece, started to get dogged (excuse the pun!). So on
Tuesday 12th it was covered up with wooden panels by Joe Ozlala, the
owner of the building. An artist himself, he said he had already been
hoping to turn the building into a gallery, so maybe the Banksy can
somehow be included. After some pressure it was uncovered again
on the 17th and shortly afterwards it seemed to have a coating/
varnish applied over it. Then some transparent plastic went on top.

Status
See above. I wonder what will happen to it next (April 2011).

LDN25

LARGE GRAFFITI SLOGAN (SOME ASSEMBLY REQUIRED)
[A.K.A. IKEA PUNK]

This was first spotted on Friday 18th September 2009 on Beddington Farm Rd in Croydon and was probably done in daylight earlier on that day. It was at the northern end of this long road by the roundabout and Endeavour Way (postcode: CR0 3DY. Map/GPS reference: TQ 30224 66799). The punk contains elements of a recent canvas, known as 'Don't Forget Your Scarf', that Banksy did for his Bristol Museum exhibition just a few months previously.

As usual the placement was excellent if perhaps a little 'safe' compared to other recent ones. It is on a small wall sandwiched in a row of five massive billboards. If you framed a photograph of it carefully you could get the twin towers of Croydon IKEA in the background.

They built IKEA on the site of an old power station and IKEA kept the two brick chimneys – giving a statement to where their shop is and keeping some heritage from what the site used to be. To make sure their cultural imperialism could be rammed further down our throats they put their colours at the top, illuminated them at night, and whinged about how much they cost to maintain. I may be biased of course because the old Bristol Rovers ground at Eastville is currently an IKEA store and they've now even got rid of the final pylon of the old floodlights – grrrrr!

By the Sunday it had already been dogged a tiny bit. After the word 'smash' it said 'silky' and had a rude word underneath it (see photo). After a strong period of street activity in London (see Locations LDN17 and LDN19) Banksy's website was updated on 25th September and included a photo of this.

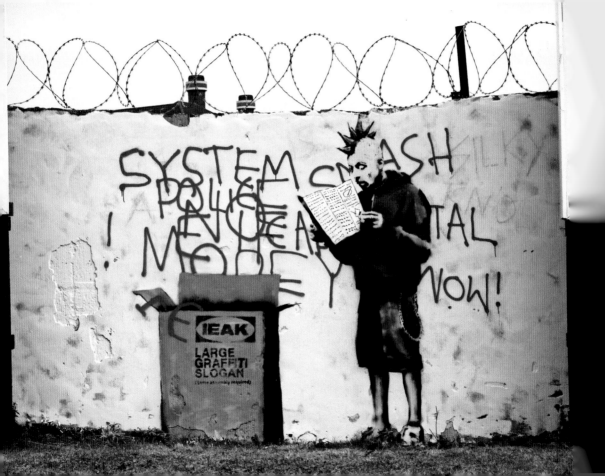

By Monday 28th Sutton Council were asking their residents to comment via an email address named 'art or graffiti' on whether this should stay or go. Councillor Colin Hall, Executive Member for Environment on Sutton Council, was quoted as saying: "We will... be keeping an open mind from this and await feedback from the public before deciding what to do with the wall." Later it was reported that 90% of people who responded to the survey said the work should stay on the wall.

In early October it was quite seriously dogged with numerous tags, and on 11th November the *Sutton Guardian* reported that the company that owned the wall (concrete company Hanson Premix) had totally removed the wall to save it from vandalism. A company spokesman said "At this stage we don't know what we're going to do with the wall" and the news article reported that the company may retain it for private use or could put it on display somewhere for people to enjoy it. Later in November it emerged that the removal was actually the idea of two opportunistic men who approached the company. One of them is quoted as saying "We really want to sell it to a gallery or a museum so the maximum number of people can enjoy it. But if we can't do that, there is always eBay."

So nothing new there. It basically comes down to money, as usual.

The *Torygraph* (cough, I mean *Telegraph*) later reported that these blokes had spent £30,000 on extracting it from the ground and preparing it for sale, and had moved it to a "secret location in the North of England" (yeah, coz obviously Northern people are stupid and don't know what art looks like); but were disappointed to find that it couldn't be authenticated. D'oh! In August 2010 I noticed it was being touted by Bankrobber Gallery. I hate giving them publicity, but I do want to document what has happened to this piece. By October it was up for sale on eBay (ooh, classy), with a starting bid of £25k, and a reserve higher than that. The listing mentioned that the wall clean-up had been done by Wall Paintings Workshop. They were the company involved with Pensioner Thugs (see *BLT Vol 1*).

STEAM ROLLERED TRAFFIC WARDEN

In late August 2009 a photo flew around the 'net of an image of a squashed traffic warden on the front 'wheel' of a steam roller in South London. No other information came out. Most people (including me) weren't convinced it was by Banksy and it wasn't even clear if it ever physically existed. However when his website was updated in late September it was featured, so it was 100% by him.

Shows how much most of us know.

Some people managed to find exactly where it existed, in Lewisham. The roller was still there. It had moved a bit though and there was no actual evidence of this stencil ever being on the roller, unless it was perfectly parked so you couldn't see it under the roller.

But imagine if the roller had been used to flatten hot tarmac since the picture had been taken. If so, presumably the image would have rapidly and comprehensively disappeared.

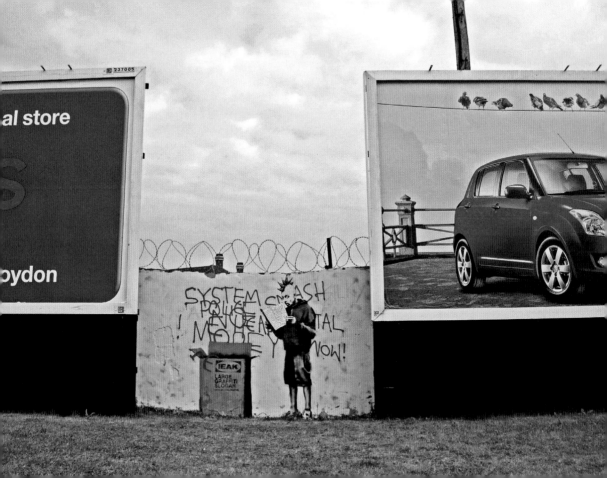

EAT THE RICH *
(* with our new 2 for 1 offer including a choice of wine)
After a heightened period of street activity in London (see Locations
LDN17, LDN19 and LDN25), Banksy's website was updated on
25th September 2009 to include photos of those pieces, but also
surprisingly included a photo of this piece which no-one had yet
seen.

 Within a few frantic days it had been 'found' in Deptford by avid
Banksy fans. It was on Frankham St, Deptford, SE8 4RG, near Giffin
St and Deptford High St.

 Within a few more days it had been whitewashed. It didn't even
last long enough for many people, myself included, to get a photo of it.

 The slogan reminds me of the Motörhead song of the same title
and P.J. O'Rourke's book also of the same title which calls capitalism
'the worst economic system anyone ever invented, except for all the
others' (although I don't think that's a totally new observation).

EAT THE RICH*

* With our new 2 for 1 offer including a choice of wine

NO PARKING

LONDON (CALL CENTRE) CALLING

Photos of this first emerged on Flickr on Sunday 10th October 2010, and the following day a photo of it was added to Banksy's website, simply labelled 'Clash'. It was presumably done at the same time as the Haring Dog (Location LDN24).

It is a take on The Clash's famous record cover for their *London Calling* LP, but replacing Paul Simonon's Fender Precision Bass with a typist-style chair about to be smashed up. It made me think of a call centre worker going berserk at the drudgery of his work, hence my title for it.

Its placement may have been relevant as it was right opposite the News International building, on The Highway (A1203) in Wapping (postcode: E1 8HY. Map/GPS reference: TQ 34308 80724).

This was the 'Fortress Wapping' that led to the infamous 'Wapping Dispute' in 1986–1987 when 6,000 newspaper workers went on strike after employment negotiations failed. They were dismissed, and the new printing plant miraculously managed to run and print even more titles via members of other unions. What fortunate timing eh, that all this managed to work out so well for Murdoch? The strike lasted over a year but was destined to collapse as not even one day's production was ever lost. This dispute and the collapse of the miners' strike are credited with changing labour relations in the UK forever, and also changing the nature of the London Docklands in perpetuity.

This was one of the last locations to get into the first UK edition of this book, and was the first to leave it, because in early November 2010 it was buffed, before the book had even been printed. That's the peril of publishing real, paper books.

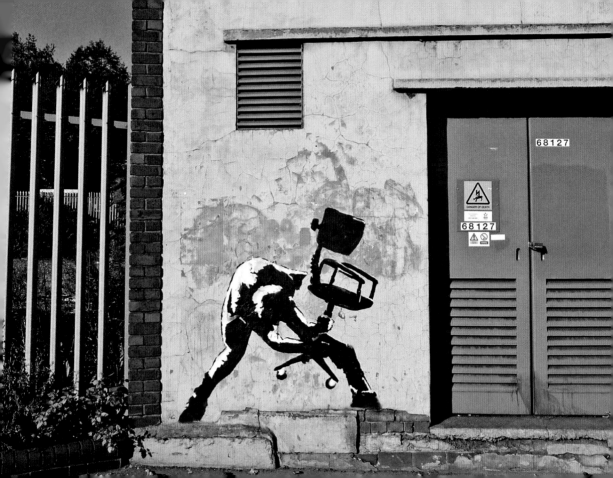

SWEEPING IT UNDER THE CARPET [CAMDEN MAID]

This was most probably done on 14th May 2006 using a large white wall at the junction of Chalk Farm Rd (A502) and Regent's Park Rd (postcode: NW1 8BB. Map/GPS reference: TQ 28179 84356).

It slowly degenerated in quality with paste-ups, stickers and general graffiti around it and over it. The wall is owned by the Roundhouse, an arts and performance venue nearby, and it almost became a sort of 'legal wall' as the Banksy piece attracted other graffiti to the wall, similar to what happened when Banksy put up 'Designated Graffiti Area' stencils around London and other cities many years ago. After months of additions and dogging, culminating in the entire face being blacked out, it was 'touched up' by the wall owners in September 2007.

In November 2007 the *Camden New Journal* reported that Camden Council wouldn't get rid of any Banksy pieces, although as usual there was huge dollop of hypocrisy over their decision to allow 'good' graffiti to remain. Conservative Environment Chief Councillor Mike Greene is quoted as saying that "There's genuine art and Banksy is an example of that. I do have a worry that some graffiti could encourage other, shall we say, less talented individuals. It's really a case of finding a balance between encouraging art the public can enjoy and having a free-for-all where every talentless rogue who decides he wants to can put his tag."

He's obviously been reading *Wall and Piece* because he then suggested introducing designated areas where artists can "go wild with a paint brush". Lib Dem Leisure Chief Councillor Flick Rea supported such areas "as long as it's interesting and done with some care and we can formalise it to some extent." So basically they want to control it, make decisions about it, and then it will all be OK. I feel they haven't quite sussed out the meaning of graffiti yet!

Someone whitewashed the piece in February 2008 and the phrase 'All the Best' was added. Within a week it had been 'restored' again.

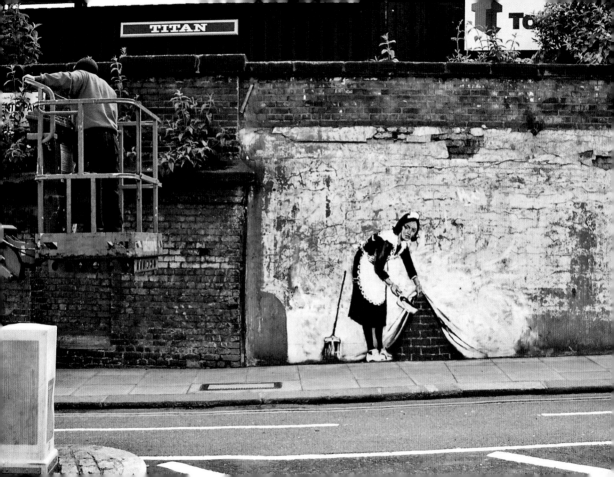

On 20th December 2008 it was whitewashed again and 'Banksy Was Here. RIP' was written in the blank area. In April 2009 a cod-anarchy sign was added to the wall. Soon after, the *Camden New Journal* quoted a council spokeswoman who admitted that "After a call from the Roundhouse we did assist them in removing the emulsion painted on the side of their building." Basically it seems like every time it got 'too bad' for the Roundhouse to accept, they organised a repaint. Hmmm.

This maid piece was slightly different to the version that was done on the side of the White Cube Gallery in Hoxton, which in turn was based on the original street version in Los Angeles done in March 2006 just before the infamous Barely Legal exhibition, which including a canvas version of it on display. The Hoxton one is no longer there but you can see it as Location S20 in *Banksy Locations & Tours Vol 1*. A drawing of the image featured on his website for a while and a photo of it was added into the paperback edition of *Wall and Piece*, which states that it took 18 minutes to complete.

Rather strangely, the *Independent* newspaper claimed that they had commissioned the piece. The (RED) edition of the *Independent*, guest-edited on 16th May 2006 by the sunglass-clad U2 do-gooder Bono, wrote "Commissioned by the *Independent*, the work can be seen as a metaphor for the West's reluctance to tackle issues such as AIDS in Africa. Banksy said yesterday that the commissioned piece was also about the democratisation of subjects in works of art. 'In the bad old days, it was only popes and princes who had the money to pay for their portraits to be painted' he said. 'This is a portrait of a maid called Leanne who cleaned my room in a Los Angeles motel. She was quite a feisty lady'." In the next day's paper the following red faced 'Clarification' was printed: "we reported that the street painting featured by Banksy was commissioned by the *Independent* newspaper. A spokesman for the artist said: 'Banksy does not do graffiti commissions for national newspapers and is unlikely to start at any point in the near future.'"

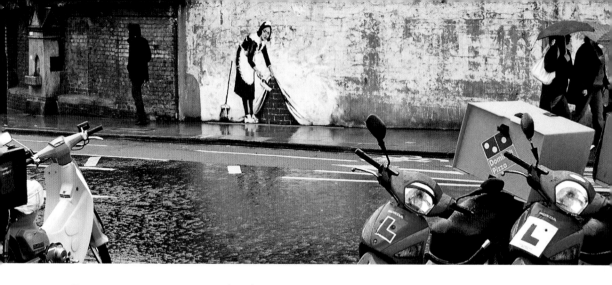

There was a later connection to (RED) though. In February 2008 many artists joined forces with Damien Hirst and (RED) to auction off contemporary art in New York to raise money for AIDS relief in Africa. Most of it was specially-made rather than some old tat they had lying in a drawer, including a collaboration between Banksy and Damien Hirst called 'Keep It Spotless'. The catalogue described it as "a Damien Hirst Pharmaceutical (spot) painting which Banksy has defaced". It was a version of the maid, over the top of a spot painting, and was sold for a staggering $1.87m. Hirst explained how it happened, "I handwrote letters to everybody.... He (Banksy) said, 'Give me a painting and I'll mess around with it.' I love his work and I have to say I like my own. I think it looks brilliant, doesn't it? Sweeping it under the carpet."

LDN29

THE CANAL PACK

In *Banksy Locations* & *Tours Vol 1* we had 'The Rat Pack' (four different Banksy rats in Clerkenwell) and in *Vol 2* we are lucky enough to have 'The Canal Pack', four very different Banksy pieces that were within a short walk of each other along the South side of the Regent's Canal in Camden. They were all first spotted on Saturday 19th December 2009 so were probably done the night before with the help of a boat. Numbers 2 to 4 were west of Camden Lock, clustered under the Oval Rd bridge and Gloucester Avenue train bridge (Map/GPS reference – TQ 28505 84022). Number 1 was slightly east of Camden Lock under the Camden St bridge (Map/GPS reference: TQ 29080 84099).

The history of each one is given below; three of them were finally buffed in mid-August 2010, whereas the 'Aristorat' survived a little longer, until about January 2011.

In January 2011 a new piece was placed on the wall under the Camden Street Bridge (see photo overleaf), but it seemed to bear no relation to the previous work, and for once it also didn't stoke the Banksy/Robbo 'feud'! At the time of writing (May 2011) that one is still there.

1) 'My Parents Think I'm a Painter and Decorator'

This my title for the decorator who looks like he's putting up graffiti wallpaper (see photo right). Banksy has said before that his parents don't know what he does and that they think he's a painter and decorator. Rather like the 'Leopard' in Location LDN23 that made an image out of an already graffitied wall, this one cleverly used the existing graff. Within a few days this one was featured on his website and in January a photo was added of how the original piece by veteran writer 'Robbo' looked before Banksy incorporated it into his work. Whether Robbo thought it was quite so clever is another issue. Robbo did the landmark piece that Banksy's piece went over and many hardcore writers expressed offence on the internet as it had been there for a staggering 25 years, right under the British Transport Police's HQ at 25 Camden Rd of all places, and Banksy's actions could be deemed disrespectful to a seasoned writer.

The placement of this piece also reminded people of a quote in the recent book *London Handstyles*, where Robbo is quoted as saying, "I was out one night with a load of old writers and got introduced to Banksy. He asked what I wrote and I told him, he cockily replied, 'Never heard of you' so I slapped him and said, 'You may not have heard of me but you will never forget me.' I thought he was very rude and disrespectful." So people wondered if Banksy really did have a beef with him and did it deliberately?

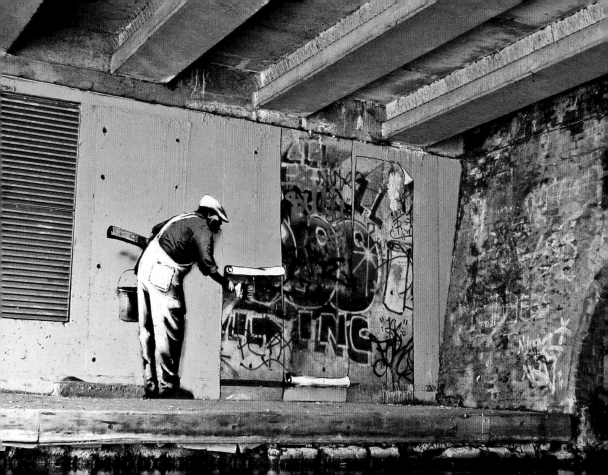

In an interview in August 2010 the artist Eine mentioned that an 'incident' did indeed take place at his birthday party *many* years ago. Whatever exactly happened yonks back, Robbo swiftly went to Camden on Christmas Day and put up a 'King Robbo' dub on the wall, cleverly making Banksy's decorator look as if he's writing it (see photo right).

I can understand the offence taken by some writers, but I do find the reaction slightly hypocritical. Writers go over each other all the time, and not necessarily due to any bad feeling. It's often just part of the graffiti life-cycle, lack of suitable space and needing to practice. And I do slightly wonder if some of these internet debaters really are 'prolific' writers; I would have thought prolific writers might have better things to do with their time. There also seemed to be a heavy dollop of childish hatred of Banksy and of an outsider who dares to do well for himself and do pieces in London (back in an 2003 interview Mr. B mentioned how London writers treated him as a country bumpkin). Even Robbo himself later said, "I consider it fun" (rather than war).

On 31st March 2010 all four pieces were amended yet again. This one had three rather predictable and puerile letters added in front of 'king', matching the chrome and black dub already there. Thankfully a week later Team Robbo came back and reversed this addition so it was back to normal.

After a buffing, and then another Robbo piece, it was quiet until a new piece arose in mid-January 2011. For once it didn't (obviously) stoke the 'feud', and seems to be merely a rather whimsical chalk line drawing of a living room scene (later used in April in the Art in the Streets exhibition at the Museum of Contemporary Art in L.A.). The only bits of colour are where the intricately sprayed goldfish jumps from his bowl to an idyllic desert island painting on the wall. A (real) burnt-out armchair was added to it a few days later, complete with astute chalk lines, but was gone by mid-February. The photo of it on Banksy's website in February called it 'Camden Gold' (as in 'goldfish' presumably).

2) Tag Fisher

A typical old-fashioned Banksy boy is seen fishing by the canal and catching a Banksy tag like an unwanted shopping trolley (see photo overleaf). The subject and location reminds me of the Fisher Boy at Bermondsey Wall West.

In mid-January 2010 it seemed like Robbo amended this one as well. The boy was now fishing out a sign reading 'Street cred', and a message next to it read 'Banksy – did you think it was over? Team Robbo'. In an interview Robbo explained that "Team Robbo stands for all of us freehand graffiti writers and not your stencil street art middle class art students." On 31st March, it was amended yet again. The Robbo words were sprayed over and the sign was changed to a 'No Fishing' type sign (see inset photo overleaf). A week later Team Robbo came back and changed the fishing sign to 'Vote Robbo', and wrote next to it, 'Banksy – By

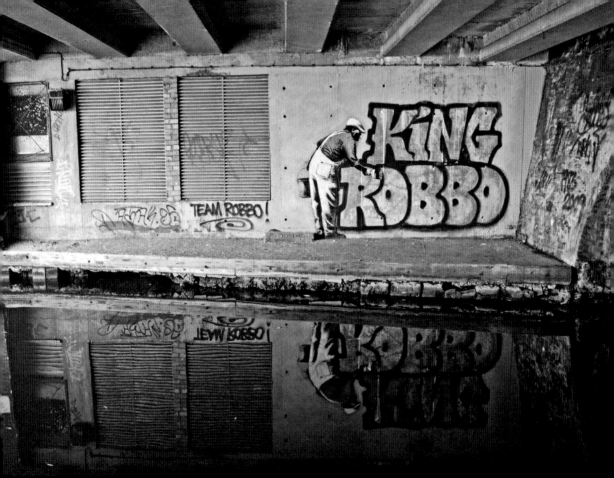

being in London your [sic] depriving your village of it's [sic] idiot'. I love the irony of calling someone out as being thick, but then getting the spelling/grammar wrong yourself! In May the 'Team Robbo' bit was scrawled out by someone, and 'Robbo Die' was added, in large, basic letters. This was getting tedious.

3) I Don't Believe in Global Warming
This slogan, perfectly placed on the canal side wall of a large white apartment building, half in and half out of the water, was perfectly timed just a few days after the Copenhagen summit descended into typical selfishness. On the 25th January 2010 it was also amended by 'Team Robbo' to read 'I don't believe in war', plus a comment next to it that 'Its to [sic] late for that sonny – Team Robbo'. On 31st March, it was amended yet again this time presumably by Banksy. The wall was totally whitewashed and replaced with what looked like a hand-finished stencil of a stork with a paint roller for a head, as if it had painted the wall.

A week later Team Robbo came back and added the following Monty Python *Life of Brian* reference to the wall, 'BANKSY – He's not the messiah, he's a very naughty... '. Paint drips from the roller now deftly added to the illusion that the stork painted it. See the inset photos overleaf.

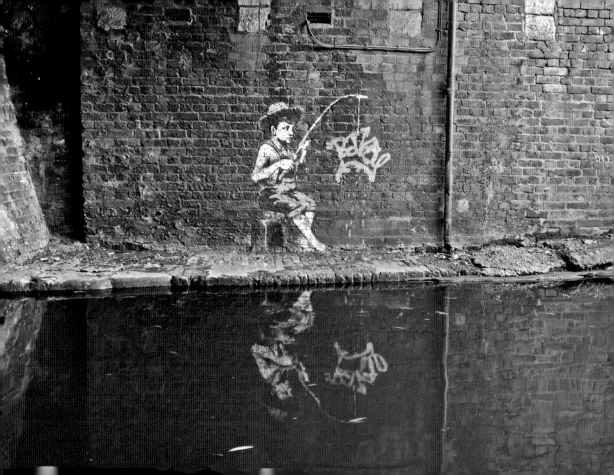

4) Aristorat

This is a strangely small but elaborate rat, in top hat and tails bearing a cane and cigar. Not the usual rat you find along a canal. The Banksy vs. Bristol Museum exhibition in mid-2009 incorporated a mock-up of Banksy's studio which included a small sketch that this rat must be based on.

On the 25th January 2010 this one was also added to with a comment next to it that read 'Team Robbo – Banksy La Rat!'. It is probably a reference to a heavily over-quoted, self-deprecating comment by Banksy that "Every time I think I've painted something slightly original, I find out that Blek Le Rat has done it as well. Only twenty years earlier." On 31st March it was amended yet again with a circular haze of black spray now covering up the Robbo words, thus leaving the rat looking like it was on the opening credits of a Bond film or in the spotlight of a theatre stage. A week later Team Robbo came back and added a new comment: 'Shoe shine sir only 10c – Robbo working class and proud!'. This is a reference to a Photoshopped image from a person on Facebook purporting to be Banksy, which mocked Robbo's real life profession, shoe repairing. However Banksy's website clearly says "Banksy is not on Facebook, Myspace, Twitter or Gaydar", so I would suggest that Team Robbo got their Y-fronts in a twist about nothing on that occasion. It was amended yet again in September 2010, with just the 'Banksy La Rat' comment this time, and finally buffed around January 2011.

Photo: Sam Martin

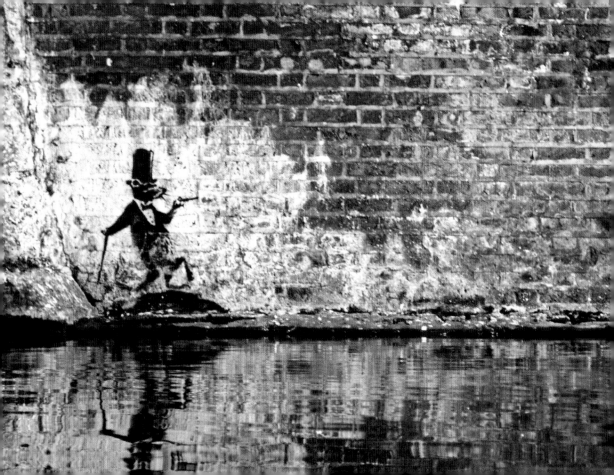

LDN30

GRAFFITI REMOVAL HOTLINE

This was executed in late May 2006 PSE (pre-scaffolding era).

For about a month this dwelled on the south side of Pentonville Rd (A501) opposite the Jury's Inn Hotel, until Islington Council's 'Clean Street Team' came along and jet-washed it off. A shot of the jet-washing is in the paperback version of Banksy's book *Wall and Piece*. A photo of it is also shown in the *B Movie* added extra that is part of the *Exit Through the Gift Shop* DVD release.

This was one of four uses of the same 'kid' stencil. See Location LDN6 in this book and Location S25 in *Banksy Locations & Tours Vol 1* for another two.

It was also a re-use of the Graffiti Removal Hotline stencil first seen at Location LDN22, and another example of a large piece put up without problems adjacent to a very major road!

LDN31

TESCO FLAG/VERY LITTLE HELPS/ALLEGIANCE TO THE FLAG

Postcode: N1 8LY

Map/GPS reference: TQ 32102 84066

Location: On the side of Savemain Pharmacy at 166–168 Essex Rd, N1 8LY. They even featured it on their website for a while. It's close to the crossroads of Essex Rd (A104) and Canonbury Rd (A1200).

This is called 'Tesco Flag' on Banksy's website but the print version on Pictures On Walls was called 'Very Little Helps' (a play on the Tesco advertising slogan 'every little helps') and a canvas version from Laz was labelled 'Allegiance to the Flag'. It was most probably done Sunday 2nd March 2008.

Within about a week the main image, but not the flag, was covered in a sheet of transparent plastic. On 25th March the pharmacy owner slightly misguidedly took the plastic off and covered the wall in a sort of anti-graffiti varnish to stop any dogging of it. It didn't seem to work, though, and turned the whole wall brown like a fake tan! On 19th April 2008 I stumbled across a workman putting the plastic back on and sealing the edges (see inset photo overleaf). In late May 2008 the Tesco bag was whitewashed over, but it was later restored and then covered with plastic. In 2009 'God Save our Baracksy' was painted on the plastic.

Unlike his reception in other areas, Banksy got the seal of approval from Islington Council. Deputy Leader Terry Stacy is reported as saying, "I quite like it, I went down to see it yesterday. We won't be removing it unless the owners ask us to. And it is a wonderful endorsement of the council's campaign against plastic bags." A spokesman for Tesco made the following pithy and surprisingly subtle reply: "we're flattered to have been thought of by one of the UK's foremost contemporary artists. However, we're not art critics and will leave it to individuals to decide on its poignancy."

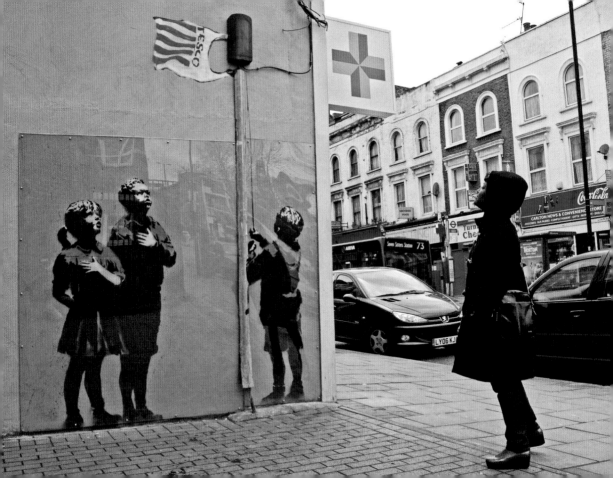

More importantly though in these times of war and famine, a newspaper whose name I don't even like to whisper asked "Is Banksy Backing the *Mail* Campaign to Banish the Bags?" The evidence the article gave was irrefutably overwhelming: "It appeared on the side of a chemist shop in Islington...just days after the *Mail* launched the Banish the Bags campaign." Spanners!

It is shown in the *B Movie* that is part of the *Exit Through the Gift Shop* DVD special features, and includes some short comments from Greg Foxsmith of Islington Council.

A one-off canvas based on the image and entitled 'Sketch for Essex Rd', was donated to the 'Art 4 Ken' campaign in March 2008 as part of the fundraising efforts to re-elect Ken Livingstone as Mayor of London. The reserve was £75,000 but it actually sold for around £195,000. This later caused a minor problem though as purchases of more than £200 have to be classed as a donation to the Labour Party with strict legal rules attached. The party asked for the advice of the Electoral Commission and as there was no way of checking Banksy was a 'permissible donor' the party had to give £75,000, the original valuation of the piece, to the gallery and it could then accept the rest. The Electoral Commission's register lists that on 14th April 2008 Banksy's then agent Steve Lazarides made a donation to the National Labour Party of £121,600. The canvas was later sold at Sotheby's in October 2010 for only £82,850.

In March 2009 *Guardian* journalist Simon Hattenstone, who famously did the only major newspaper 'face to face' interview with Banksy in 2003, organised an auction of 'celebrity pants' in aid of the New North London Synagogue's Destitute Asylum Seeker Drop In. Instead of real pants Banksy donated a large one-off painting based on the Tesco Flag, but with a pair of Union Jack underpants replacing the Tesco carrier bag. The eBay listing quoted Banksy as saying: "I think it's the duty of any civilised country to provide refugees with the basics of human survival. Just because I personally only change my pants once every six weeks doesn't mean every asylum seeker should

have to do the same." Despite wild speculation of a £100,000 value, it only just staggered above its starting bid of £30,000.

In early March 2010 the 'flag' was amended to read 'HRH King Robbo', presumably as part of the fallout from the now epic and continuing 'Robbo' incident. In December 2009 Banksy amended/ went over a very old piece by veteran writer Robbo on the Regent's Canal in Camden (see Location LDN29) and all hell broke loose afterwards. They actually took the plastic off, amended it, and put it back on. In July 2010 a large 'Slayer' tag was sprayed twice on the plastic, but it was removed almost quicker than I finished this sentence. In October a real Tesco plastic bag was added on it.

I can't end this location without a bit of geek history. There used to be a small Banksy microphone rat just to the side of the derelict Art Deco cinema opposite and a pair of cutting rats on the cinema itself, but both have long gone.

Nearest Transport: Essex Road train station is virtually next door but visitors may prefer the convenience of the tube stations at Highbury and Islington (Victoria line and limited rail services) and Angel (Northern line). They are further away, though.

Status
Still looking good but covered in fake tan and transparent plastic (May 2011).

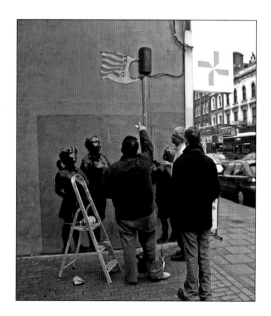

LDN32

MUSEUM GUARD

This was on Martineau Rd (postcode: N1 1ND. Map/GPS reference: TQ 31495 85569) for six years but was whitewashed just before I was doing my final checks for this book in the summer of 2010. It was a stone's throw from Arsenal's Emirates Stadium.

This may not be an archetypal Banksy piece but it was definitely by him as the exact piece features in both the *Cut It Out* and *Wall and Piece* books; the latter of which dates the piece to 2004. A similar one was also done in Liverpool for the Art Biennial in 2004 and I think there was also one in Clerkenwell for a while. Some Banksy rats also lived nearby in 2004.

By November 2007 the *Evening Standard* was reporting that it had already been 'retouched' five times by Islington Council workers, who painted out tags on the piece. Lucy Watt, Deputy Leader of the Council and executive member for environment, defended the policy and said, "We take a very hard line on graffiti... However, residents have been telling us Banksy is in a class of his own, his art sells for thousands, and they don't want us to remove the work. Because of the quality and renown of Banksy's work in Islington many people want to see it preserved." She also admitted that it's not an official policy and is done on a "case-by-case basis".

In February 2008 it was partly covered by a strip of white paint roller-brushed right up the middle of the guard. Next to it were the words 'All the Best'. This was a pretty similar attack to what happened at the same time to the 'Cash Machine and Girl' in Farringdon (see Location F12 in *Banksy Locations & Tours Vol 1*). The inset photo shows the state of it in spring 2009.

Sometime between April and July 2010 the whole wall was totally whitewashed. I suspect it must be have been done because the house it is next to, and to which it presumably belongs, was being renovated and they wanted everything looking 'clean and tidy'.

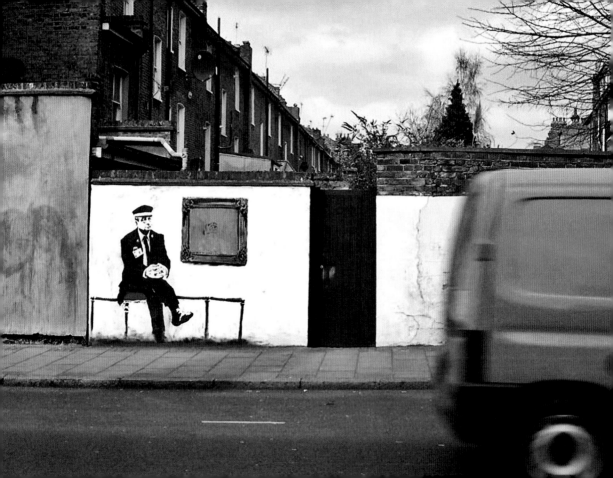

LDN33

LAST GRAFFITI BEFORE MOTORWAY

This was done on the evening of Saturday 28th February 2009 and took the relationship between a new Banksy graffiti and the internet to new levels. At 11 p.m. a guy reported on an internet forum that he had just driven past something that must be a new Banksy. He had previously driven past there at 6 p.m. on the way back from yet another Arsenal failure to score and it wasn't there at that point. He soon went back and by 1 a.m. photos were on the internet and he was reporting that a tarpaulin, crate and gaffer tape were still there.

Several years ago a new Banksy piece was hardly news and barely 18 months ago it took days and weeks for much interest to be aroused. By 2009 it was now taking barely hours for it to spread around the 'net.

It was on a small brick sub-station that is right on the junction of where the North Circular Road (A406) meets the Great North Way (A1, the road that takes you up to the M1 motorway; hence the graffiti's message). The small power station belongs to Transport for London (TfL) and they were initially undecided about what to do about it. It mattered little as around 18th March it had the word 'priceless' crudely painted all over it, as shown in the inset photo. The *Daily Mail* ran an article on this, including photos of a man they describe as a 'graffiti artist' doing the damage. In early May 2009 it was totally buffed.

An early pencil sketch of this could be seen in the Banksy vs. Bristol Museum show in June–August 2009. It was part of the myriad of images in the mock-up of Banksy's studio, and actually had the words as 'Last Vandalism Before Motorway'.

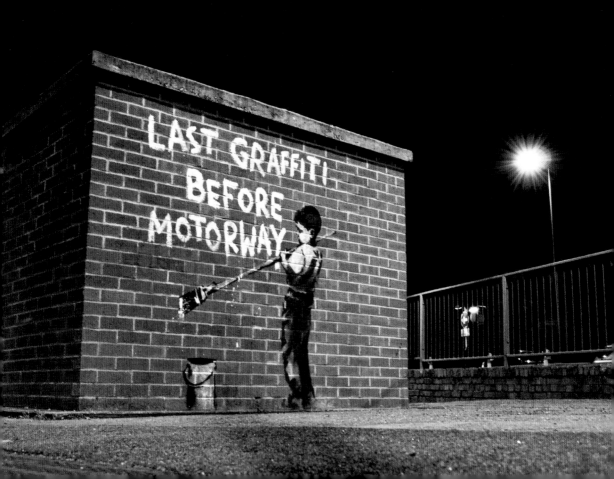

LDN34

HITCH HIKER
Postcode: N19 5LW
Map/GPS reference: TQ 29308 86919
Location: On the very south end of Highgate Hill (B519) by the
junction with Tollhouse Way (the Archway Roundabout). Only a poke in
the eye with a wet fish away from Archway tube station.

This piece is only visible coming down the hill as it's in an alcove, and
is thus excellent placement as usual. It's rather un-Banksy-like, but it
is definitely by him; either that or he is featuring other artists' work
in his *Wall and Piece* book. It shows Banksy's rather twisted vision
of Charles Manson as a hitchhiker; possibly the worst hitchhiker you
could pick up, bar Rutger Hauer of course! If you wait a while, you
can get a photo with a bus coming past, making it look as though he
really is hitchhiking.

In 2008 it started to attract dogging with some spray above the
head making it look a bit like he had bunny ears. In late March 2009
the hitchhiking board was changed from 'anywhere' to '10foot'
(for another location hit by that 10foot's dogging campaign against
Banksy's street work, please see Location S12 in *Vol 1*).

In early March 2010 the board was amended to read 'Going
Nowhere' and 'Team Robbo' was sprayed near the feet, presumably
as more collateral damage from the now infamous 'Robbo' incident
(see Location LDN29 if you missed the low-down on what happened).
In mid-March the 'Team Robbo' words were buffed, possibly by the
Council, and at the end of the month the board was totally blacked out.

Nearest tube: Archway (Northern line – High Barnet branch)

Status
Still there, and pretty good despite the amendments listed above
(June 2011).

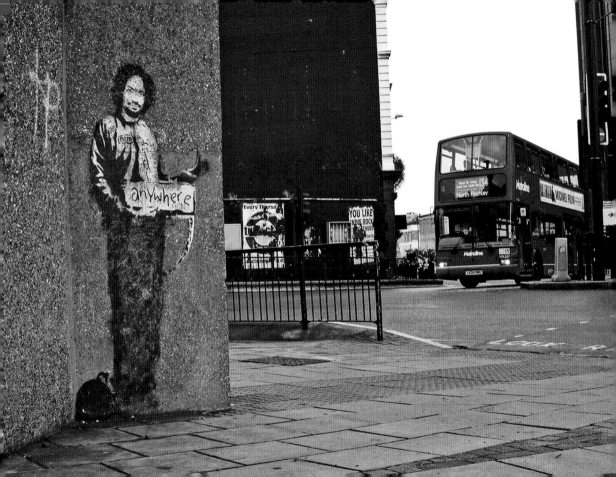

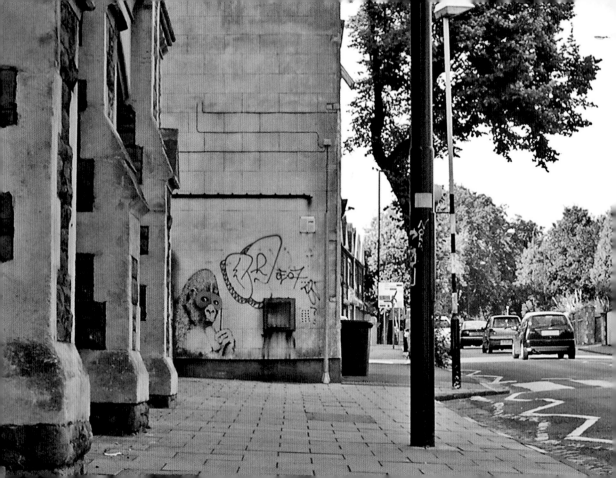

BRISTOL &
THE WEST COUNTRY

SW1

GRIM REAPER/'THE SILENT HIGHWAYMAN'
Postcode: BS1 5LW
Map/GPS reference: ST 58807 72412
Location: On the hull of the Thekla, a famous floating club and gig venue moored at the floating harbour. It's moored at The Grove (East Mud Dock, Bristol, BS1 4RB) but you'll need to go to Merchant's Quay on the other side of the harbour to see the reaper (use the Prince Street Bridge).

The full story of this was given in Banksy's *Cut It Out* book, with an abridged version in *Wall and Piece*. The story goes that one night in May 2003 Banksy went out rowing and painting. After he had done a message about the slave trade on a nearby bridge, which not surprisingly didn't last long in slightly paranoid Bristol, he made the "slowest getaway in criminal history" and did a 'Banksy!' throw up on the side of the Thekla. A photo of that one is shown in the *B Movie* added extra that is on the *Exit Through the Gift Shop* DVD. Soon after the Harbour Manager told the Thekla he had looked at it with City councillors and they had ordered its removal. It was allegedly painted over rather hastily and the Thekla were not too happy about this as they had quite liked it. Before the situation could get too out of hand Banksy "went back and dropped a grim reaper in a rowing boat on the same spot in the hope we can lure him [the Harbour Manager] out and go for the full custodial sentence this time".

The image of the reaper seems to be based on a 19th century etching illustrating the pestilence of The Great Stink in 1858. It was used by *Punch* magazine on 10th July 1858 and was entitled 'The Silent Highwayman'.

Status
The boat and the reaper both remain there to this day (May 2011).

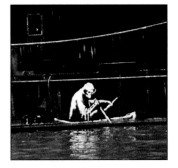

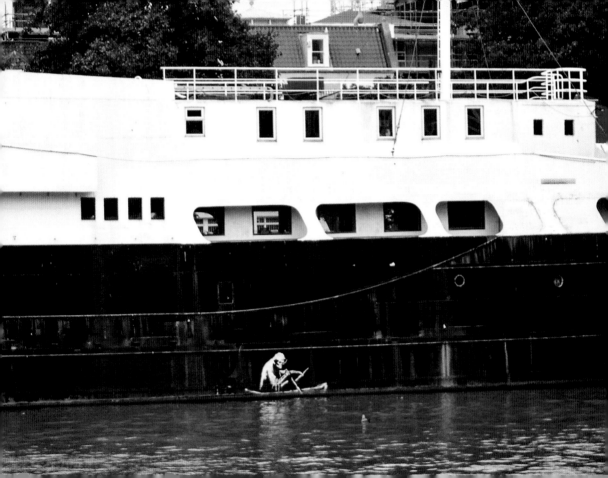

SW2

WINDOW LOVERS

Postcode: BS1 5HS
Map/GPS reference: ST 58329 72882
Location: It's actually on the side wall of the buildings on Frogmore St but most people view it from the bottom of Park St (A4018) opposite the east end of the massive City Council building.

This appeared on Sunday 11th June 2006 and was possibly the first time that Banksy used scaffolding and tarpaulin to cover a wall so he could peacefully do his work inside. It sparked a huge debate in Bristol over whether it should stay or go and what is 'art' and what is 'vandalism'. An on-line consultation and vote in June and July 2006 helped the Council to decide on its future and people overwhelmingly asked for it to stay.

When a journalist asked Banksy about this piece for her article in the *New Yorker* in May 2007 he said, "I think because it turned out there was a sexual-health clinic on the other side of the wall helped, which just goes to show – if you paint enough cr*p in enough places sooner or later one of them will mean something to someone." And his opinion on the City Council's decision to preserve it was that, "I think it's pretty incredible a City Council is prepared to make value judgments about preserving illegally painted graffiti. I'm kind of proud of them."

A photo of this on Banksy's website is labelled 'Window Lovers' and a photo of it was added into the paperback version of *Wall and Piece*. A photo of it was also briefly featured in his splendid film *Exit Through the Gift Shop*.

In the night of Monday 22nd–Tuesday 23rd June 2009 it was hit by six splodges of blue paint, presumably from paint bombs or similar. The BBC quoted Councillor Gary Hopkins of Bristol City Council as saying, "I'm disappointed but unfortunately not surprised. People are built up and then there are always some people who want to drag them back down again. I think the turning point in his reputation was when we decided to keep this piece of work but maybe that destroyed his street cred."

Obviously taking that fully on board, the rather eccentric Councillor 'Spud' Murphy rapidly proceeded to try to clean it off himself! After a few hours on his own cherry picker he realised it was rather complicated and left the wall with the spots where two and a half of the splodges were now looking much lighter than the original stonework used to be.

Status

Still there
(May 2011).

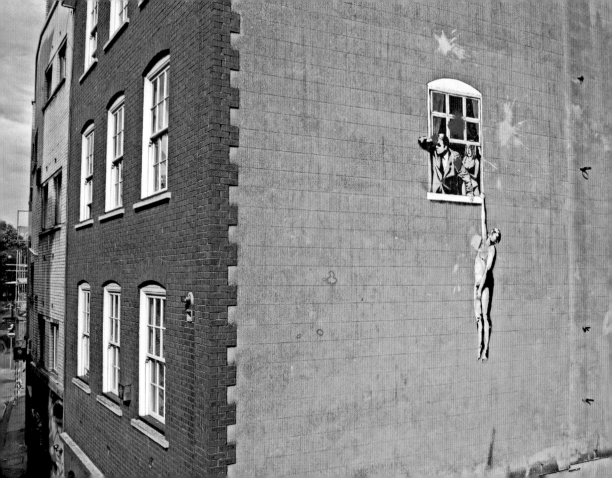

SW3

SNIPER

Postcode: BS2 8DJ

Map/GPS reference: ST 58630 73332

Location: Above 22 Upper Maudlin St, just off Park Row, opposite the Bristol Royal Infirmary (BRI). This is on the side wall of what was at the time the 'Honey Pot' pub, but it has now become an office for the 'Wallace and Gromit's Grand Appeal' which raises money for the Bristol Royal Hospital for Children (BRHC). The shop underneath the wall is called Fire Works Gallery and Studio.

This was most probably done on Sunday 30th September 2007, as people first seemed to spot it on Monday 1st October. This is called 'Sniper' on Banksy's website.

 People with far too much time on their hands have mentioned that the stance is not correct for a sniper and that although he is holding the rifle with his left hand, it is actually painted as though he is right-handed. They are totally right, but rather pedantic. I should know, as I am a self-confessed pedant and when I was very young I once made up a business card that read 'Trained Assassin – Aromatherapy Also Available'.

Status

Still there, looking perfect (May 2011).

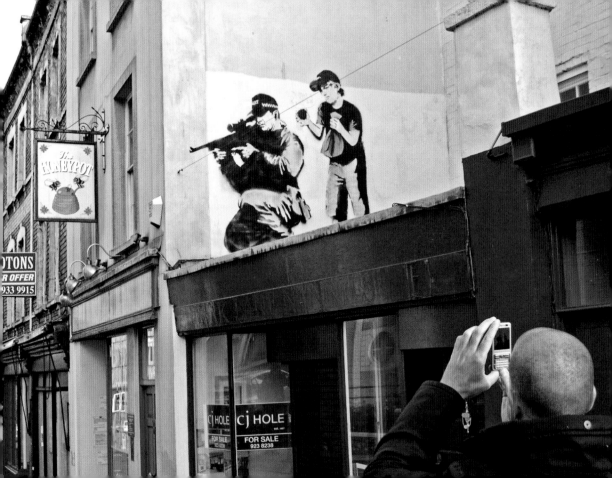

SW4

MILD MILD WEST
Postcode: BS1 3QY
Map/GPS reference: ST 59132 73933
Location: This esteemed piece can only be seen going downhill
(Southbound) on Stokes Croft, opposite the junction with Jamaica St.
It's easy to miss otherwise.

The story of how The Mild Mild West was created is recounted in
detail in Steve Wright's excellent *Banksy's Bristol – Home Sweet
Home* (Tangent Books). The story is told by Jim Paine the man who
got Banksy to do it. Jim owned Subway Records in Bath, where
incidentally I used to get my vinyl from many years ago.

The Bristol free party scene was suffering a more hardline
approach from the police, especially at a New Year's Eve warehouse
party on Winterstoke Rd in 1997–98 when the police broke it up with
a lot of force. After Jim opened a Bristol branch of Subway Records
on Stokes Croft in 1998 he invited Banksy to paint the side wall. After
weeks of thinking with Jim, Banksy settled on using the Winterstoke
Rd episode as his inspiration. As Jim says, it showed "a teddy bear
with a Molotov cocktail in his hand – it was showing a mix of hard and
fluffy that was the free party scene." It was done over three days
in early 1999, with the rozzers done as late as possible as that was
the most provocative part. They needn't have worried as it's never
attracted any significant controversy, which is rather ironic when
the local rag runs a campaign against his clumsy tag on the M32
bridge rather than this piece! In 2007 a BBC website poll voted it
the 'Alternative Landmark of Bristol', beating off competition from
Troopers Hill, the Purdown radio mast and the multi-coloured houses
in Totterdown.

In autumn 2004 'Connelly and Callaghan' purchased the building
next door, the former 'Finance House' (now called Hamilton House),

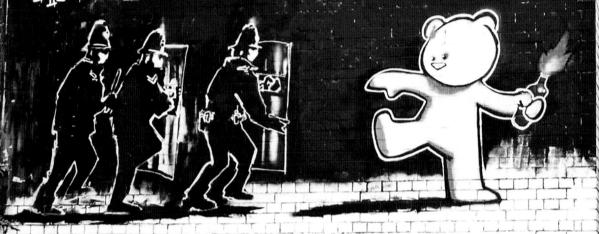

as a development opportunity and as a HQ for themselves. In February 2007 they applied for planning permission to convert and extend the existing office building into 79 residential units, retail/cafe units, and office space. Although the MMW is actually on the side of the neighbouring building, 76 Stokes Croft, the development runs right up to the pavement, so the MMW would be inside a proposed glass atrium front to the building. Amended plans were approved in December 2008. Critics say it will rob us of 'public' art. The developers say the atrium will be freely accessible to the public, and the graffiti will still be visible from the street anyway, through the glass. Currently (May 2011) the building is successfully run by Coexist, a local Community Interest Company, and is (thankfully) nothing like the plans above, so I'm rather confused about what is happening. Let's hope it stays as it is.

The piece remained untouched and much loved (many people regard it as their favourite Banksy piece ever) for a full 10 years until it was splashed with red paint on 6th April 2009, probably from a paint-filled fire extinguisher. A photo of it is shown on Banksy's new DVD. A group calling themselves Appropriate Media 'claimed responsibility' for this as though it was a major world event. I couldn't actually give a monkey's what they stand for and all the pointless arguments about Banksy 'selling out' because he makes money from his art. All I'll say is that I bet Banksy has got up 1,000 times more than they ever have and has done more to help others than they and many others have.

Within hours Chris Chalkley, Chair of the 'People's Republic of Stokes Croft' community group, was up a ladder trying to clean the paint off. With help it was washed off relatively easily and looked pretty good. In June 2009 it happened again, the night after 'Window Lovers' was attacked – see Location SW2. It was blue paint this time, and the PRSC again successfully cleaned it off almost immediately.

Status
Still there (May 2011).

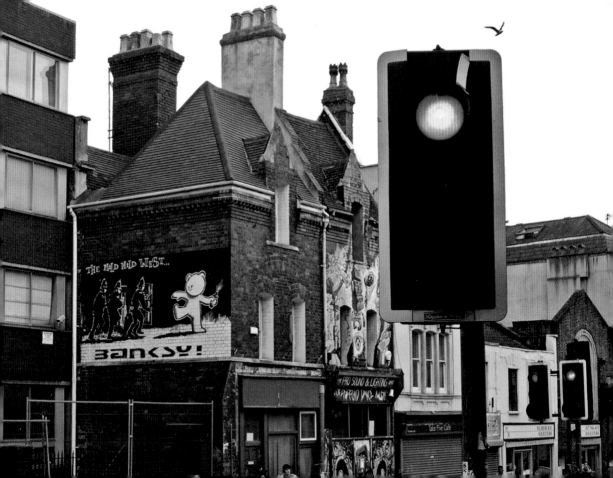

SW5

ROSE & TRAP

Postcode: BS2 8NG
Map/GPS reference: ST 58978 74042
Location: This has been on a wall on Thomas St North since at least late 2003, just a few metres up the very steep hill from the excellent Hare on the Hill pub on Dove St.

The image it is based on can be found towards the end of the *Banging Your Head Against a Brick Wall* book where the comment next to it reads, "It's great when you love someone so much you can sleep with other people behind their back and it doesn't even matter." When I first saw it, it was still clean, but in July 2007 it looked like someone had tried to remove it because a large section of the wall was damaged. By the end of August the wall had been repaired and repainted and in early September at least 20 local residents clubbed together to pay for a sheet of transparent plastic to go over it and a frame to be built around it. In December some rude graffiti appeared to the left of it complaining that Bansky's graffiti gets preserved and framed. By the middle of 2008 it was getting dogged. In April 2009 the rude graffiti next to it was painted over but a second version of it rapidly replaced it. Last time I saw it, it had been cleaned up again, so it does seem as though the local residents will keep it clean and 'preserve' it.

There were other examples of this image in Bristol but they have all long gone.

Status

Still there (May 2011).

SW6

THE NEW POLLUTION/PURE CLASS

This was on a breeze block wall on Sevier St next to the junction
with Ashley Hill (B4052), for almost 10 years before a housing
development came along and suddenly knocked it down one day in
August–September 2006.

The mural included what looked like a giant jasper (a wasp to those
not from the West Country) wearing a gas mask and had 'Dedicated
to Pure Class...' and 'Abi. Rest in Peace' written at the bottom of the
wall. 'Abi' was Abigail Clay, who was well known and well loved in the
local area. But she tragically had a fatal asthma attack while out with
friends at the Thekla on 27th November 1996 (see Location SW1 for
the Thekla). The year after, Banksy and friends of Abi painted the
mural.

The breeze block that had the Banksy tag on it soon appeared on
eBay and the local paper, the *Bristol Evening Post*, ran stories about
the whole situation. I got into a bit of a row with the brick seller as I
felt strongly that it was pretty insensitive to try to flog it.

Springdale Developers apologised for destroying it, saying they
didn't realise the significance of the mural, and they later named the
new development 'Abi Clay Court' in honour of Abi. All in all, a pretty
sad end to an emotional local landmark.

A similar mural was painted on the side of a truck in 1998. For
several years it used to be seen at the Glastonbury Festival, and was
also at the Eclipse Festival in Cornwall in August 1999. It apparently
now lives in Spain.

THE NEW POLLUTION

BANKSY

DEDICATED TO PURE CLASS... ABi REST IN PEACE

PLAYING IT SAFE

Until recently this existed on an out-of-the-way grey wall on Stafford Rd in St. Werburghs, near-ish the junction with Tewkesbury Rd (Map/GPS reference: ST 60370 74619).

Another one of these rare early stencils existed near Clifton until 2009. Both read 'Playing it safe can cause a lot of damage in the long run' and all the times I've seen photos of this work it always came with a star above it.

The image was also used on the large piece he did for the Walls on Fire event in 1998 in Bristol.

This work in particular, and other script-based stencils in general, may well be influenced by the work of American artist Jenny Holzer, who uses text as art and is often most well known for her series of statements, political texts, and aphorisms ('truisms') expressed on the streets using diverse methods.

In 2010 the wall was suddenly getting quite heavily graffitied, including some right on the Banksy tag itself. In May–June the whole wall was whitewashed so it seems like after probably over a decade of easy survival this Banksy had become the unwitting 'victim' of a wall getting so messy that something actually gets done about it.

PLAYING IT SAFE
CAN CAUSE A
LOT OF DAMAGE
IN THE LONG RUN

SW8

CAT & DOGS

Postcode: BS5 6JY
Map/GPS reference: ST 61023 74645
Location: On the side wall of the Kebele centre on Robertson Rd, Easton, near the junction with Foster St.

This was part of another very old mural, probably from 1998, that Banksy contributed to when he was part of the 'Dry Breadz' (DBZ) crew. The wall was painted by Verse (aka Soker), Pert (aka Lokey), Tes and Kato, and few people even realised that one section was by Banksy.

Banksy's section shows a cat writing on the wall as two dogs walk by. The writing above reads, "There are crimes that become innocent and even glorious through their splendour, number and excess", which is a quote from the 17th century French author and nobleman François, duc de La Rochefoucauld. It appeared in the first two editions of his 1665 book *Réflexions ou Sentences et Maximes Morales*, usually simply known as *Maxims* in English, before it was suppressed by the author in later editions. There is actually a second part to the original epigram, "thus it happens that public robbery is called financial skill, and the unjust capture of provinces is called a conquest." Still as relevant today as it ever was!

In 2007 the Kebele centre controversially painted a fresh mural along the wall, but left most of the Banksy bit alone, as if suggesting that the Banksy piece was somehow better than the Verse, Tes etc. The Ghostboy stencil by the Kebele window was also painted around and preserved (see inset photo).

Status

Still there (May 2011) but sometime in mid-March 2011 a large silver tag was dropped in the area where the cat is spraying. Given the context it doesn't actually look too bad.

Ghostboy

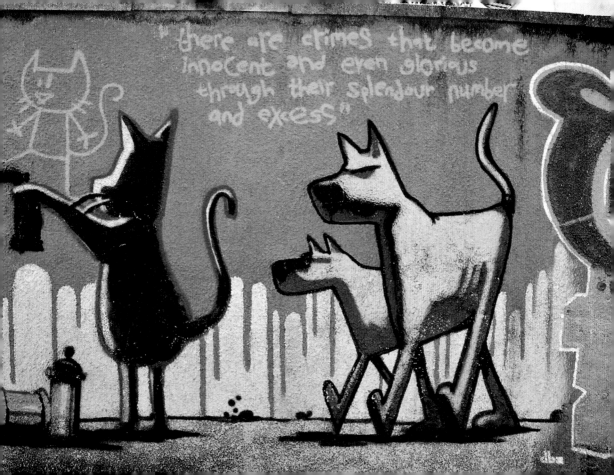

SW9

QUEEN VICTORIA

This was on the metal shutter of a shop on the corner of St. Mark's Rd and Brenner St in Easton, near Stapleton Rd (A432), and may have dated from about 2002.

The story of this exact Queen Vic is featured in Banksy's *Existencilism* book and partly in *Wall and Piece*. *Existencilism* gives the following anecdote: "Some people thought a picture of Queen Victoria ruling over her subjects was a bit too rude to paint randomly around a city. So I did quite a few and then they all got buffed pretty quickly. But one of them was on the shutters of a shop that sells total cr*p seven days a week. They don't shut until 9 o'clock at night and only then do the shutters come down. This gives the stencil a kind of adult-only rating as it never gets seen before the 9 o'clock watershed."

I've actually seen the shutter down several times before 9 p.m. but the general premise is fair and it's a good yarn anyway. Sometime between August 2006 and August 2008 the shutter was replaced with a new one. I don't know exactly what happened to the old shutter and the people in the shop weren't very forthcoming when I asked them.

There were other Queen Vics in Bristol, such as the one on Whiteladies Rd, and one on the corner of No.1 Somerset St in Kingsdown (close to the 'Rose and Trap' at Location SW5), but they have all long gone. Another could previously be found in Blackfriars (London) in 2002.

This is the same image as the print version sold many years ago by Pictures On Walls (POW).

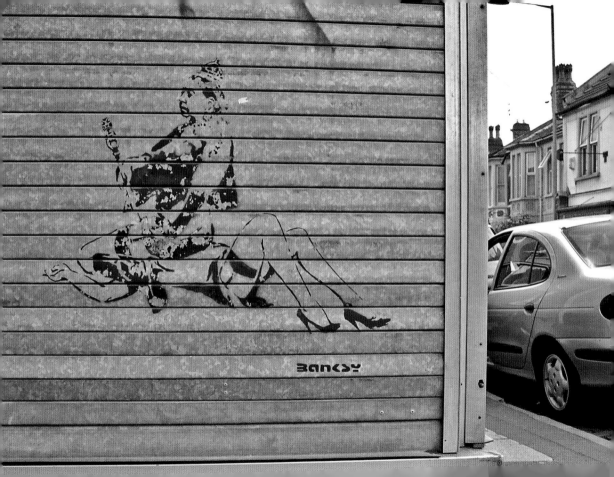

SW10

VISUAL WARFARE (WITH KATO)

This old skool wall on the aptly named Cato St in Easton (postcode: BS5 6JF. Map/GPS reference: ST 60971 74503) was actually first painted by Kato in 1998 with a flying kung fu figure on the left and the central wild style bit. A mark up of the full piece showed that a man coming in through a door on the right side would have finished it off but I don't think that side was ever completed. The left side was then re-done by Banksy and he filled in the right side. The whole piece became known as Visual Warfare with Kato's original 'Bad Applz' signoff now removed. A small photo of it is shown in *Wall and Piece* (on the early pages, which are mainly full of Bristol pieces) and it is also shown in the *Exit Through the Gift Shop* special features.

In 2007 the owner of the house put the whole house up for sale via an art gallery, using the Banksy as the selling point. Which led to an important question – does absolutely everyone own a gallery these days? Not long after, in mid-March 2007, Council workers turned up and it seemed like they were about to paint over it like they had wrongly done to 'New Forms' earlier that same day, but local residents gave them a right old earful. The workers rather bizarrely removed the 'Cato Street' sign (uh? why? and it has never been returned) and quickly left with their tails between their legs. The media reported it as 'residents stop whitewashing' although the Council claimed they were never intending to buff it.

This is all pretty much academic now anyway, as not long after, in April 2007, someone splashed the mural with paint, seriously disfiguring it (see the bottom inset photo). In mid-2009 it also had 'What a Load of Pollox' scrawled over it and the wall lingered on in a complete mess. Kai One finally did a totally new piece on the wall in December 2009 so nothing now remains.

SW11

MONKEY BOMBER

This was on St. Mark's Rd, approximately opposite Heron Rd, on a small alcove wall just outside a garage/small workshop. It was done in about 2001–2002. The story goes that the owner of the garage had just moved in and had freshly painted the wall when next day this stencil appeared on it. Many years later, in February 2008, the BBC reported that the owner, Martin Trent, had cut it out of the wall after fearing it might not survive too much longer. He said, "I liked it on the wall, but the other graffiti was getting closer and closer and I'd heard of a few being painted over."

I bumped into Martin whilst I was taking a photo of the empty wall in August 2008 (the wall now had breeze blocks covering up the massive hole the removal had caused). He asserted that people who know Banksy say that he did do the stencil. Well, this image has certainly been used by Banksy in the past including long-gone uses in Ashley Rd and Whiteladies Rd, and is also observable in *Wall and Piece*. The news report said he'd already been offered £20,000 for it, but Martin just enjoys having it around and although it's not on active sale he is open to the right offer. Hmmm…

In June 2009 it was on display at the View Art Gallery in Bristol.

It's no surprise that Easton had a lot of Banksy street pieces as he used to have a studio in the area and apparently lived just down the end of this road in the 1990s.

Note the 'Rowdy' tag underneath it. Check out www.farmyardeez.com and his output as part of the Souls On Fire (SOF) crew, as well as his more recent collaborations with the Beyond Chrome/Burning Candy posse.

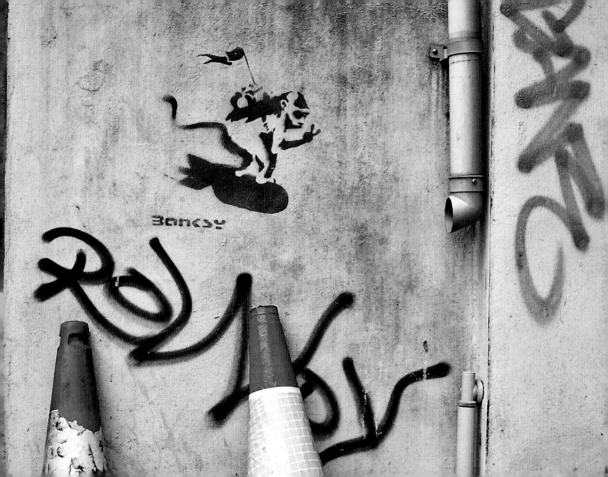

SW12

GORILLA
Postcode: BS5 6SP
Map/GPS reference: ST 61295 75009
Location: This beauty is on the side of the North Bristol Social Club,
145–149 Fishponds Rd (A432), Eastville, BS5 6PR, next to the
New Testament Church Of God. It's opposite the White Lion Inn and
Coombe Rd (i.e. near the Muller Rd section of this long-ish road).

This appeared in mid-June 2007, and was relatively quickly tagged
around. Rather strangely many people at first didn't believe that this
was by Banksy. But in July 2008 a drawing of this image appeared
on Banksy's website, which not only ended once and for all any doubt
over the street piece, but also re-iterated just how good an artist
Banksy really is. It also reminded me of what Banksy wrote in his
books, that "All artists are prepared to suffer for their work, but why
are so few prepared to learn to draw?"

And in *Existencilism* he wrote "If you want to say something and
have people listen then you have to wear a mask. If you want to be
honest then you have to live a lie." Although this was written long
before the gorilla was painted, and was presumably more about his
anonymity, it does maybe give some insight into his thinking about
'masks' in general. Some people call this 'The Perfect Disguise'.

Status
Despite many additions around it and one tag directly on it, the actual
piece itself is still generally in excellent condition (May 2011).

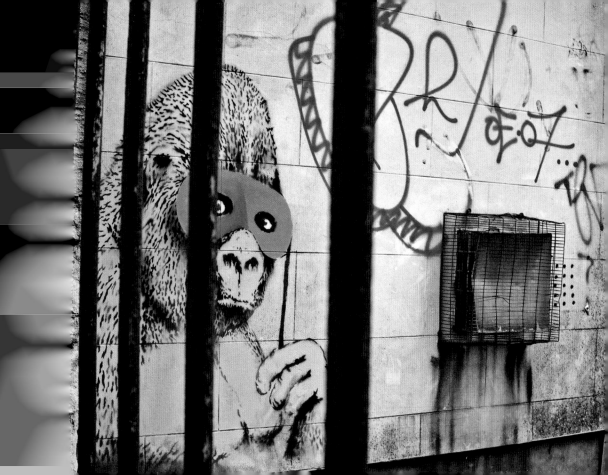

SW13

THIS IS NOT A PHOTO OPPORTUNITY
Postcode: BS27 3QF
Map/GPS reference: ST 469 542
Location: In Cheddar Gorge, Somerset, halfway up a rock face

This actually isn't as difficult to find as it might sound or look (the photo perspective makes it look high up but it's actually not that far from the road). The easiest way to find it is to drive along Cliff Rd (B3135), which is the long road that winds its way through the gorge, and find a small lay-by towards the touristy/shoppy end of this magnificent gorge. This rough lay-by is on the north side of the road opposite a small water pumping station and is one of the first with free parking, as opposed to the tarmaced car parks which need to be paid for. The stencil is about 40 metres up the steep rocky path.

When I first spotted this by total accident in mid-2004 (I didn't even know Banksy had done anything this far out of the city!) there was also quite a large tag on a metal box inside the pumping station. I've since lost my photos of this tag and by my return in 2006 (see inset photo below) it had been buffed but you can still just about see the outline if you look hard enough. This exact graffiti is shown in *Wall and Piece* alongside the comment that "Tourism is not a spectator sport."

There is other Banksy history in the area. An image of a parachuting cow has been seen on the rock face of the gorge but I don't believe it is still there now and I heard that the animals at his July 2003 Turf War exhibition in London came from the Cheddar area.

Status
Still there (April 2011).

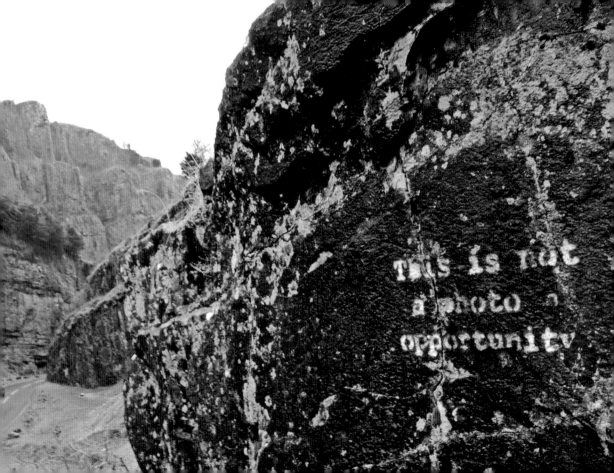

SW14

PILTON FRISK

This was on a small outbuilding, an old toilet block I heard, on the eastern edge of Glastonbury (postcode: BA6 8DD). The building is on the north side of Chilkwell St (A361), which is the main road to Shepton Mallet. It's between the Bere Lane roundabout and the junction with Wellhouse Lane, the lane which goes up to the Tor and has the famous Chalice Well on the corner.

It went up a few days before the Glastonbury Festival started in late June 2007 and became a sort of 'Welcome to the Festival' piece, as many people would travel that way. Later that year I took my mate Sam on a West Country tour and when we got there on 26th November 2007 it had mainly been whitewashed. The teddy bear and lunch box still remained, but even they were then boarded up in July 2008. No-one else had reported the whitewashing before so it possibly happened only just before our visit. Sam's photo of it was used in the 'Next' section on Banksy's website, which used to show what happened next to Banksy pieces.

It was called 'Pilton Frisk' on his website, so that's what I've called it.

In June 2008 a new stencil went up on the same wall. It was labelled 'Jay Zeavis' and featured a blinged-up Michael Eavis, the organiser of the Glastonbury Festival, squatting in Jay Z's customary pose. It was presumably a reference to the Eavis family daring to book Jay Z to headline the festival that year. Some thought it was by Banksy but it clearly wasn't. It was actually by an artist called Syd.

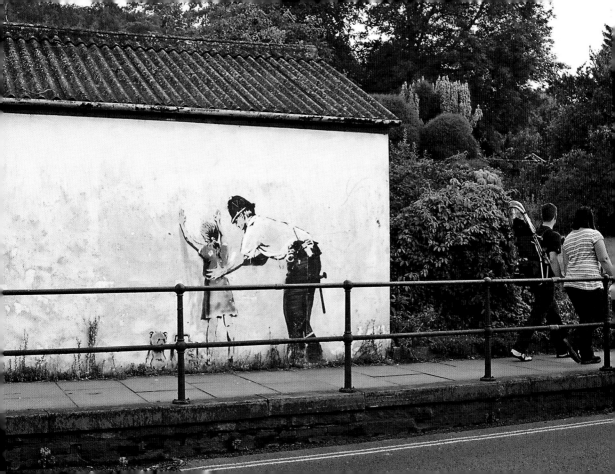

SW15

ZEBRA CAR

This old car (painted with stripes in 2004 by Banksy) looked brilliant when newer, and there is a great photo of it in *Wall and Piece*. By the time I found it, it had been moved towards the edge of the quarry (map reference circa ST 71516 45576; BA11 3LY is the closest postcode), and later it became just a wreck really. It is in Westdown quarry, which is the southern quarry, as opposed to the Asham Quarry, the northern one, north-west of Nunney in Somerset (a few miles from the A361), and it is really hard to find — if indeed it is worth finding anyway, as there is some doubt it is still there because I heard a rumour about the roof being sold on eBay. This locality is sometimes referred to as Dead Woman's Bottom after the area at the entrance to the abandoned limestone quarries, which is just south of the village of Chantry. I usually park on an un-named side road directly opposite the entrance to the quarries just where the footpath starts (map reference ST717461). If coming from the Nunney area on the main road (Somer's Hill), this is the next turn after Stony Lane, which is the main-ish road to Chantry. I always get lost in this area, even with a map!

A public footpath runs directly through the quarry and few people use the area, so a wander around the quarry is quite interesting anyway (especially the old wreckage and workings). Numerous painted rocks by Rowdy from the Farm Yardeez (and Souls On Fire and Burning Candy crews) can still be seen on the Asham Quarry side (see inset photo right). Check out www.farmyardeez.com.

In the late 1990s an 'eco-camp' was set up here protesting against road building near the Whatley Quarry. When the camp was raided the story was apparently reported with the headline 'Police Enter Dead Woman's Bottom'.

Rowdy (circa 2003)

SW16

BOXHEAD

Postcode: TQ2 5HG
Map/GPS reference: SX 91033 63883
Location: On the whitewashed side wall of the Grosvenor Hotel on Belgrave Rd in Torquay, Devon.

A photo of this (labelled 'Boxhead') first appeared on Banksy's website on 11th October 2010 along with the Haring Dog (Location LDN24) and the London Calling piece (Location LDN27). It's quite a sweet and nostalgic painting of a robot being drawn by a kid with a DIY robot box on his head. It cleverly uses an existing ventilation grille and for a short time it remained 'unfound' by humans (well, from the growing posse of Banksy fans at least).

A local blogger had reported that he saw it on this road from the 7th but this info wasn't picked up by Banksy fans until a separate Twitter post on Friday 15th showed the piece in Torquay. Put the info together and you had the exact location. On Saturday lunchtime it was boarded up but it was only temporary until some transparent plastic could cover it properly the following week. I therefore had just managed to see it fresh and was also there at the opportune moment to capture the cheesy land train coming past. A nicer transparent plastic covering, with smart white border that blends into the background well, was unveiled in April 2011.

Looking back it seems like Banksy may have been in the area to support the Street Art Jam that was being held at the Paignton Lighthouse on the 9th and 10th.

Status

Still there with transparent plastic on top (May 2011).

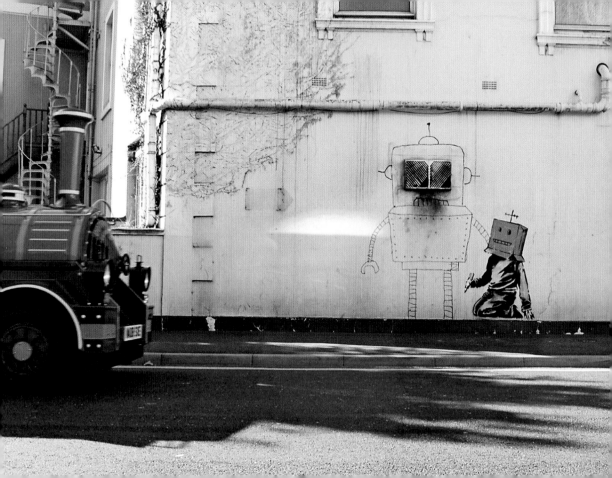

BRIGHTON & LIVERPOOL

B&L1

KISSING COPPERS

The infamous Kissing Coppers image got buffed almost straight away when it was put up in London at Broadwick St in the Bohemian Soho area, but it survived very well on the side of a pub in Brighton until it was attacked, and later become a victim of Banksy's growing popularity.

This piece was on the side of the Prince Albert pub, at 48 Trafalgar St, Brighton, BN1 4ED, close to the train station. Note the small Banksy tag at the bottom of the wall to the right of the lamppost. When it was originally done (2004 I think) there was a no parking sign just to the right of their heads that made it even funnier I think, as it read 'At Any Time', as if kissing was illegal.

My photos of it are from mid-2006, before the mayhem happened. In October 2006 two middle-aged guys from the less than aptly named town of Peacehaven came along in the night and obliterated it with black paint. Strangely they had turned up in a works van, plastered with company info so they were very quickly caught! In December they pleaded guilty to criminal damage and both got a six-month conditional discharge. By February 2007 it had been repainted and restored, presumably not by Banksy, and covered in transparent plastic. In mid-May 2008 it was temporarily covered by a large wooden box and soon after it was reported that it had been 'peeled off', sold and replaced with a copy. Hang on though, it was already a repaint job, so someone now owns a 'Banksy' that was actually a repair of the original anyway? As they say, there's 'nowt so queer as folk'. Or art collectors.

In 2008 a large paste-up by Snub appeared next to it. In July 2009 large writing saying 'Plastic is forever' was added above it. In September 2010 it was still there, covered in transparent plastic and with a wooden frame to protect it. Hmmm... have they forgotten that this is a copy of the original? Someone had also sprayed 'Poor Banksy they put you in a frame' next to it.

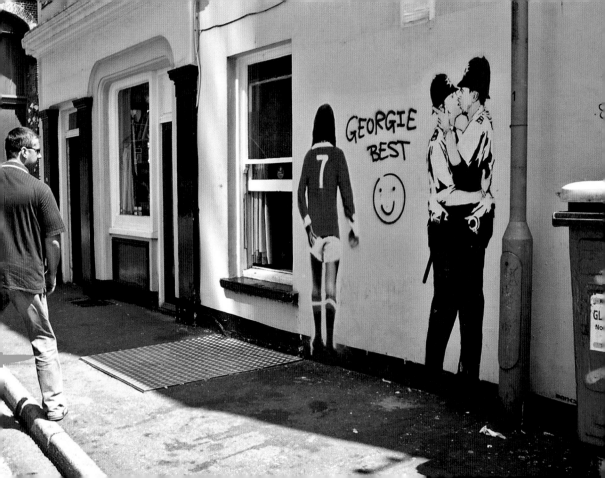

B&L2

VOTE LESS

This was done in early 2005 on the 1st floor side wall of the Sussex Stationers shop, 37–37a London Rd (A23), Brighton, BN1 4JB. It's a Banksy image that I don't believe has ever been used anywhere else. Note the small Banksy tag on the wall (bottom right).

My best colour photo of it was slightly poor. I had only managed to get a couple of 'point and shoot' photos, in gloomy light, before it was gone. So I've borrowed one from my mate Sam that is actually in focus. I find that being in focus tends to help.

In a time when some countries force people to vote, and others throw money at advertisers to encourage a disillusioned public to the ballot box, this has an alternative message to 'Vote Less'. It once featured on Banksy's website, alongside the following comment: "60% – Iraqis who voted in the country's first ever free elections despite threats of violence. 51% – Britons who say they are 'certain to vote' in this year's general election." It's slightly curious how this piece survived for so long on a major road (the A23 London Rd) in perfect condition but then suddenly someone decided to totally whitewash it in early 2007. If you look hard you can still vaguely make out the image.

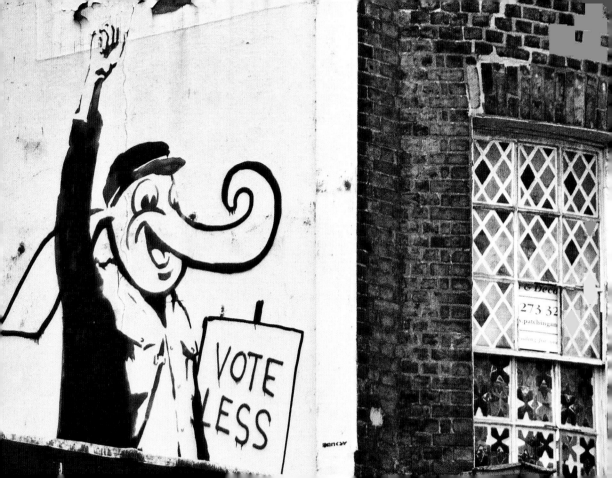

B & L 3

TESCO SANDCASTLES
Postcode: TN38 0BH
Map/GPS reference: TQ 79682 08782
Location: Along the sea front of St. Leonards on Sea (A259), near Marine Court. Not far from the Parish Church. It's on the back of a set of steps which lead down to the beach. Look for the flag pole.

Just as I was finishing off the UK edition of this book, three new Banksy pieces popped up on the South Coast. This one was first spotted on Tuesday 24th August 2010 and was possibly done the weekend before, during Hastings resident Eine's 40th birthday celebrations. A photo of it appeared on Banksy's website on the 31st.

When debate rose over whether it should be buffed, Ben (Eine) was very to the point when the *Hastings and St. Leonards Observer* quoted him as saying, "If the Council leaders decide to get rid of it they are idiots." The Council swiftly and rather creepingly got behind it. The *Observer* quoted Councillor Jay Kramer, deputy leader of Hastings Borough Council, as saying: "I think this is great. I know that we have a zero tolerance policy on graffiti, and that is absolutely right. However, we have to be flexible so on this occasion I have agreed that Banksy can be an exception to our rule and can stay." Ok, so basically it's one rule for one and a completely different rule for another, and 'zero tolerance' doesn't mean zero anymore?

By 28th August it had been covered in sheets of transparent plastic and a poor quasi-Team Robbo attempt was made to dog around it. Within a few more days the plastic had been smashed, a full 'Team Robbo' slogan had been sprayed above it and generally it was looking like a mess. The Council then cleaned it up and put on thicker plastic and sealant along the top, and it looked really good again (see photo). But I do wonder if they really know what they are letting themselves in for!

Status
Still there (May 2011).

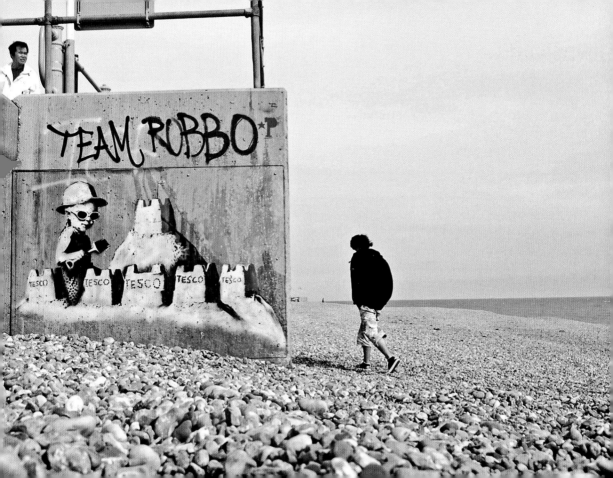

B&L4

PETROL VULTURE

This beautiful stencil was the second of two new Banksy pieces that popped up on the South Coast in late August 2010. Location B&L3 was the other.

The first most people knew about this sublime piece was when a photo of it appeared on his website on 31st August 2010. The first independent photos of it emerged later that day as the location could be deduced from the lighthouse in the photo. It was in one of the bleakest yet most enchanting places in rural England, on the Dungeness shingle headland (nearest postcode: TN29 9ND, Map/GPS reference: TR 09594 17447), not far from the lovely grey concrete nuclear power stations.

A photo of it on Flickr later showed it had actually been there since at least 24th August. I drove almost 400 miles on 2nd September to photograph it only to find that by the time I got there it had been stolen. To rub salt into my wounds, it had actually only gone earlier that day. I went all that way because I thought it was particularly photogenic, but it was on the side of an old shipping container and so was effectively only on a thin layer of plywood and must have been pretty easy to remove.

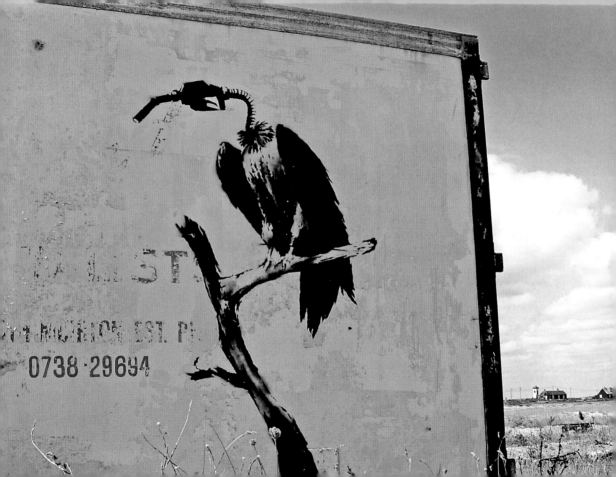

NO FUTURE

Postcode: SO14 0ED
Map/GPS reference: SU 42552 13093
Location: On Mount Pleasant Rd, near the corner with the main road, Onslow Rd (A335)

Just after I finished off the first UK edition of this book the location of this piece suddenly became known. It was in a less than salubrious part of Southampton, by the red light district (apparently... I haven't checked).

Being on a white wall gave it some photogenic qualities, and the road in front of it has double yellow lines on it so photographers were happy to get a clear shot of it.

Late on the evening of 23rd November 2010 someone weakly painted over the girl with white paint (it can still be seen underneath), and amended the slogan to read 'No Future Styles'. The apparent perpetrator crowed about it on Flickr before rapidly taking the photo down.

However, there was a school nearby the piece and the kids must have connected with it because when it was amended they stuck drawings and 'wanted' signs around it offering a reward of 10p.

It was amended again to read 'Graffiti Has No Future Styles', and 'Ooh Blanksy' was added, so it is pretty messy.

Status

As above (February 2011).

THE ISLE OF WIGHT IS ALL RIGHT

On 14th September 2010 photos of three new Banksy pieces were added to the Wooster Collective website. This site now seems to be the favoured publicity method for Banksy to showcase fresh pieces. They were: an old granny messily painting 'Keep Britain Tidy'; the slogan 'I Love You' with a computer style 'waiting' hourglass on the 'u'; and 'No Future' (see left). There were no real location clues in the photos except that they were probably in Britain (oh, that's OK then, that narrows it down). In early October it came to light that two of them had recently been buffed before any independent photos emerged (just locals and tourists had seen them). I say 'tourists' because they were actually found on the Isle of Wight of all places. 'I Love You' had been in Ventnor and 'Keep Britain Tidy' had been in Shanklin.

Given the timing of the pieces there is a decent chance that Banksy may have been passing through Southampton on the way to paying a visit to the Bestival festival on the IOW in September.

B&L6

THE KEY TO MAKING GREAT ART IS ALL IN THE COMPOSITI...

Postcode: L1 1JQ

Map/GPS reference: SJ 35048 90393

Location: On Bolton St, near Copperas Hill. Bolton St is a small side street that runs parallel to the main road, Lime St (A5038).

This is the same as the one featured at Location B&L8, but this version is on a much harder surface to work with, as it is on breeze blocks. Older photos of it show that originally the wall was incomplete, so the 'compositi' bit really did finish at the end of the wall. Great placement.

This was done during the Liverpool Art Biennial in 2004, along with all the other ones in Liverpool, most of which are now long gone (see box on the right).

Status

Still there (February 2011) but it does now have a lot of other graffiti surrounding it by a Catalan artist called Món Mort (which means 'Dead World').

B&L7

GIANT RAT
Postcode: L1 4JQ
Map/GPS reference: SJ 35163 89715
Location: On the Whitehouse, a derelict pub on the corner of Duke St
and Berry St (A5038) which despite its neglected state is actually a
Georgian Grade II listed building.

This was done during the Liverpool Art Biennial in 2004 and a friend
who was helping out there told me Banksy used a projector to trace
the outline onto the building. This exact image is featured in the *Cut
It Out* book and a photo of it was briefly featured in his film *Exit
Through the Gift Shop*. The marker pen the rat was using featured a
large Banksy 'tag' on it but it was cut out and stolen in mid-2005. A
pretty non-descript part of the artwork around the corner similarly
disappeared at some point, and most of the tail section below the tag
went AWOL in March 2009.

Liverpool was the 'European Capital of Culture' in 2008 and in
January that year the graffiti was partially covered up, despite
Liverpool City Council earlier saying it would be 'preserved for 2008'.
The pub had been identified by the Liverpool Culture Company as
one of several 'high profile grot spots' to be covered by artwork in
its 'Look of the City' campaign. A public and media outcry led them
to swiftly remove the hoarding and Sam Richards, in a web story for
LX News, very astutely commented that "This superficial change is
the kind of transformation that resembles that of a student clearing
up their house before their landlord comes for a visit, putting
cushions over the stains on the sofa. This should not be the type of
regeneration incorporated by a city that hopes to gain a higher-
profile... this funding should be directed at communities that will
benefit from it, those that are often left behind the scenes of the
media attention going on in the centre." The BBC later reported Kris

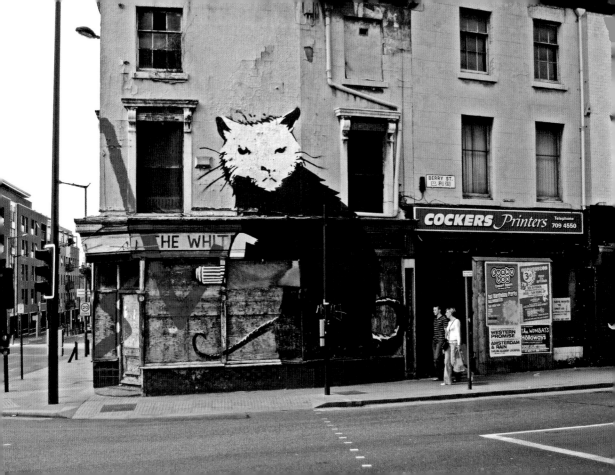

Donaldson, Director of the Liverpool Culture Company, as saying, "In addition to cleaning the building and fixing paintwork, we decided to hoard the lower part of the building to improve its appearance – a decision taken in consultation with figures in the city's artistic community. However, as a result of recent feedback from the public we have decided not to proceed with the hoarding, and all preparatory work has now been removed." Egg and face anyone?

In October 2008 the entire pub and surrounding land went up for sale, via the property agent Sutton Kersh, who said that many enquiries for it were from art dealers. Jonathan Owen, commercial sales director at Sutton Kersh, said it was a "unique opportunity" for Banksy fans. The list price was £495,000 but they expected they might get offers higher than just the alleged value of the building itself. Yeah, whatever.

It was never sold and went to auction in February 2010 where it fetched what was probably its 'true' value, £114,000, a value that didn't seem to give a squat about the Banksy. The property developer who bought it confirmed that point later when he said, "I'm not a fan of modern art, I can't say I know much about it really... I might leave the Banksy on the wall until last, just to see how it looks, but it will have to go to get the look I want."

So, it's best have a look at it whilst you can as its exact future is unclear. In January 2011 the *Liverpool Echo* reported that "The new owners of the old Whitehouse Pub ... vowed to preserve as much of the 30ft gun-toting rat* on the front of the building as they can. Ascot Property Group bought the derelict pub in November. The firm is now beginning a £200,000 refurbishment and hope it can be turned into a stylish coffee bar run by a national chain." Oh great, a national coffee shop chain. Just what we need. In May 2011 scaffolding went up over the site.

Status
Still there (June 2011).

* Note: Lazy journalists often copy what others have written rather than actually use their brain and look at a photo of it; hence they often write that it's got a gun rather than a big fat magic marker

B&L8

THE KEY TO MAKING GREAT ART IS ALL IN THE COMPOSITIO...
This one was on Seel St in the section between the side streets of
Concert St and Slater St. It was quite a well known one as the exact
piece has been featured in Banksy's *Wall and Piece* and *Cut It Out*
books, although rather atypically the publications used different
photos of it.

 The Liverpool Art Biennial is (not surprisingly) held every two
years, and in 2004 Banksy was invited to come and join in. This is
the same concept as the one featured at Location B&L6 but this one
benefited from a better surface to work with and was usually more
photogenic, often including a large colour co-ordinated refuse bin
which I quite liked! I am strange...

 I went back on 1st November 2008 but it had gone and there were
cut marks all around where it used to be. The building next door was
under scaffolding as it was being renovated into a 106-room hotel;
maybe that accidentally helped shield the disappearance of this one?
It later turned up in July 2009 at an awful 'exhibition' of Banksy ex-
street works, alongside many more favourite street pieces that we
all used to enjoy on the streets for free until they were extracted or
stolen.

 This slogan has been used on canvases at the Barely Legal
exhibition in Los Angeles in September 2006 and the Banksy vs.
Bristol Museum exhibition in mid-2009, and canvases of it have been
sold in the past as well.

THANKS & ACKNOWLEDGEMENTS

Obviously the real credit must go to Banksy, and all the writers/artists who do their work on the street. Without them, publishers would have nothing to show readers! Please support them.

The first, and biggest, thanks is for Stef who started this whole crazy thing off by asking me in one of those fuzzy Friday afternoon moments if I had ever thought of making my free tours, information and photos into anything more, such as a book. I had – great minds thinks alike, eh? – but the locations book mapped out in my head was about Eine, not Banksy. That is how *Banksy Locations & Tours Vol 1* started. He also pushed me all the way through the process, and did all of the painstaking graphic design and put up with my perfectionism. After a lot of hard work *BLT* arrived and for the next few years he carried on helping me with anything related to *Vol 1*, gave me hints and tips whilst I wrestled with this follow-up book, and even came back to design the UK cover of this book. What a mug! But seriously, I'm genuinely not sure if this would have got done without him and I owe him so much love!

The second thanks has to be to Sam, who handled all the print management, helped me on the streets (no, he isn't actually my fixer although it may feel like it sometimes), generally encouraged me, and was always around for a chat and a wander.

Many thanks to the veritable soul duo, Sam & Dave (especially Dave), for proof reading, suggestions and improvements to a draft of the book. And to Alf Martin as well. Sorry I left it a bit late to ask.

Huge respect to Steve at 'Art of the State' and Tristan Manco, Godfathers of graffiti info, knowledge and quality photographs and writing.

It's getting increasingly hard for me to get photos of his newer works before they are buffed, amended or stolen, so I also give special thanks to the growing number of people who have let me use their photos of Banksy's work on the street. And as mentioned at the start of the book, thanks to all the people who responded to my leading questions and annoyance of where to find some of this graffiti, or who even accidentally gave some info. Particular mention must be given to anyone who contributes to Flickr, especially the Banksy group, and above all the Banksy group's fellow volunteers: Mel, Ian, Quel, Jason and Steve (again).

CREDITS

All text and photographs (bar the ones listed below) in this book are by Martin Bull. Hand printed, limited editions of his black-and-white-film photos of graffiti are sometimes available via eBay – check out www.shellshockphotos.co.uk for the latest position.

Thanks to the following photographers for very kindly letting me use their lovely photos: ↘ Dave Stuart (www.flickr.com/photos/nolionsinengland) – for the pre-plasticised photo of 'No Ball Games' in Tottenham (Location LDN16), the photo of the original 'Painter and Decorator' (Location LDN29), the photo of 'London (Call Centre) Calling' (Location LDN27), the photo of the 'Sperm Alarm' (Location LDN9), and the photos of 'Take This – Society!' (Location LDN20) ↘ Sam Martin (www.flickr.com/photos/howaboutno) – for the pre-dogging photo of the 'B Boy' in Dalston (Location LDN12), the photo of 'Vote Less' in Brighton (Location B&L2), and two of the inset photos from the 'Canal Pack' (Location LDN29) ↘ Steve (www.artofthestate.co.uk) – for the photo of 'Eat the Rich' (Location LDN26) ↘ RomanyWG (www.flickr.com/photos/romanywg) – for all the photos from the Swiss Embassy (Location LDN3) ↘ Michelle Robinson – for the photo of the Banksy rat in New York (page 8) ↘ Ray Keogh – for the photo of the 'Think Tank' piece (Location LDN2) ↘ Karl Beaney (www.beaneys.co.uk) – for the photos of the 'Petrol Vulture' piece (Location B&L4)

Many thanks again to Stef at Hoodacious for doing the book cover for the original UK version of this book, and giving general help with any graphic design/technical issues – www.hoodacious.co.uk

WEB LINKS

BANKSY www.banksy.co.uk **AROFISH** www.arofish.org.uk **BEEJOIR** www.beejoir.co.uk **BONZAI** www.flickr.com/people/24828991@N07 **BURNING CANDY/BEFORE CHROME** (Cyclops, Sweet Toof and various collaborators) http://theburningcandy.blogspot.com **CEPT** www.spradio.com **DAN KITCHENER** www.dankitchener.co.uk **DR.D** www.drd.nu **EINE** www.einesigns.co.uk **KELZO (HULME LEGEND!)** www.urbandamage.com **MANTIS** www.themantisproject.com **MAU MAU** www.mau-mau.co.uk **M-CITY** www.m-city.org **MR EGGS** www.flickr.com/groups/mreggs **ROWDY** www.farmyardeez.com **SAM 3** www.sam3.es **TRANS PENNINE NOMADS** TPN (including Crie, Era, Pryme, Replete, Rota and Sune) www.flickr.com/groups/tpn (Replete also has his own site at www.repletes.net) **WK INTERACT** www.wkinteract.com **VERMIN** http://theartofvermin.co.uk **THE BANKSY GROUP ON FLICKR** www.flickr.com/groups/banksy **ART OF THE STATE** www.artofthestate.co.uk **BANKSY FORUM** www.thebanksyforum.com **GRAFFOTO BLOG** www.graffoto.co.uk **THE MIGHTY GAS** www.bristolrovers.co.uk **TU INK** www.tuink.co.uk **THE BIG ISSUE** www.bigissue.com **HOODACIOUS** www.hoodacious.co.uk **PICTURES ON WALLS (POW)** www.picturesonwalls.com **POGO CAFÉ, HACKNEY** www.pogocafe.co.uk **MY OWN WEBSITE** www.shellshockpublishing.co.uk

BANKSY LOCATION & TOURS VOL 1

A COLLECTION OF
GRAFFITI LOCATIONS
AND PHOTOGRAPHS IN
LONDON, ENGLAND
ISBN: 978-1-60486-320-8
176 pages $20.00

When it comes to art, London is
best known for its galleries, not its
graffiti. But not if photographer
Martin Bull has anything to say about
it. While newspapers and magazines
the world over send their critics to
review the latest Damien Hirst show
at the Tate Modern, Bull, in turn, is
out taking photos of the latest street
installations by guerilla art icon
Banksy.

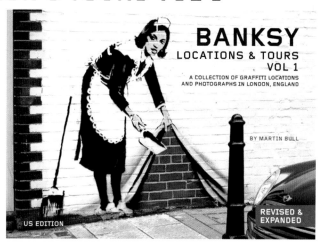

In three guided tours, Martin Bull documents sixty-five London sites where one can see some of the most important works by the legendary political artist. Boasting over 100 color photos, *Banksy Locations and Tours Volume 1* also includes graffiti by many of Banksy's peers, including Eine, Faile, El Chivo, Arofish, Cept, Space Invader, Blek Le Rat, D*face, and Shepherd Fairey.

U.S. edition has locations updated and 25 additional photos.

"Witty and thought-provoking, his images excite and infuriate in equal measure."
www.shortlist.com

ABOUT PM PRESS

PM Press was founded at the end of 2007 by a small collection of folks with decades of publishing, media, and organizing experience. PM Press co-conspirators have published and distributed hundreds of books, pamphlets, CDs, and DVDs. Members of PM have founded enduring book fairs, spearheaded victorious tenant organizing campaigns, and worked closely with bookstores, academic conferences, and even rock bands to deliver political and challenging ideas to all walks of life. We're old enough to know what we're doing and young enough to know what's at stake.

We seek to create radical and stimulating fiction and non-fiction books, pamphlets, t-shirts, visual and audio materials to entertain, educate and inspire you. We aim to distribute these through every available channel with every available technology — whether that means you are seeing anarchist classics at our bookfair stalls; reading our latest vegan cookbook at the café; downloading geeky fiction e-books; or digging new music and timely videos from our website.

PM Press is always on the lookout for talented and skilled volunteers, artists, activists and writers to work with. If you have a great idea for a project or can contribute in some way, please get in touch.

PM Press
PO Box 23912
Oakland, CA 94623

www.pmpress.org